ABANDONED
NEW YORK

THE FORGOTTEN BEAUTIES

JENN BROWN

AMERICA
THROUGH TIME®
ADDING COLOR TO AMERICAN HISTORY

America Through Time is an imprint of Fonthill Media LLC
www.through-time.com
office@through-time.com

Published by Arcadia Publishing by arrangement with Fonthill Media LLC
For all general information, please contact Arcadia Publishing:
Telephone: 843-853-2070
Fax: 843-853-0044
E-mail: sales@arcadiapublishing.com
For customer service and orders:
Toll-Free 1-888-313-2665

www.arcadiapublishing.com

First published 2019

Copyright © Jenn Brown 2019

ISBN 978-1-63499-108-7

Typeset in Trade Gothic 10pt on 15pt
Printed and bound in England

CONTENTS

ABOUT THE AUTHOR

JENN BROWN is a self-trained hobby photographer on Long Island, New York. Her photographic work centers around vacant areas and buildings of historic character. Growing up in a household of trade workers, Jenn was inculcated to a world where craftsmanship reigned supreme. Jenn's early interactions with skilled labor influenced her to art and her later career choice in textile work. Her long interest in the ornate architecture that dominated the twentieth-century American landscape was a result and would add to what she refers to as "an addiction to abandonments." The constant search, thrill, and capturing of these structures has given her purpose. Now, free from anxiety and depression, exploring has shaped her into the person she's always wanted to be.

Jenn is proud to showcase the remains of historic urban and rural architecture in New York. Her time spent in traveling and working the camera to produce a collected work mutually increased her appreciation for this subject matter and home state.

INTRODUCTION

C hildhood memories are distant and vague for some. For others, they are vivid and bright—to the point that they seem tangible. Science calls this form of recollection a "flashbulb" memory: capturing a moment in the mind like a snapshot with an old film camera. Some of my earliest flashbulb memories take me back to a school bus in the fall, on a crisp day when leaves lined the streets, in a bright array of orange and red. Suddenly, I'm a five-year-old girl gazing out the window of my bus, at what seemed to me, a vast world—my small town in Suffolk County on Long Island. One house came into my vision; it was different from all the others and intrigued me. There were boards on the windows, roof shingles torn off and the front yard full of weeds. I was too young to know the meaning behind the word "abandoned," but in the years afterwards, I would come to know its full vernacular. In my mind, that old, vacant house was somehow split, right down the center. It seemed to resemble a dollhouse in a peculiar way. It was mesmerizing, but for every bit of awe I felt at its beauty and mystery, I felt equal proportions of angst and fear.

In hindsight, the reasons for my mixed thoughts and emotions about a simple vacant house are clearer. The year before, at the age of four, I stumbled upon another house in a similar state down the road from where my babysitter lived. I recall wanting to peer inside, but my knees grew shaky and my palms sweaty as I drew closer to the building. I could not bring myself to go inside. I approached the house, just close enough to put my hands to the cold siding of the building. I looked down from outside the basement door and a small rectangular object caught my eye. It was a blank diary, one I eventually kept and wrote in for years. Like other childhood interests, I left behind this fascination with the unknown that lay behind boarded doors and windows.

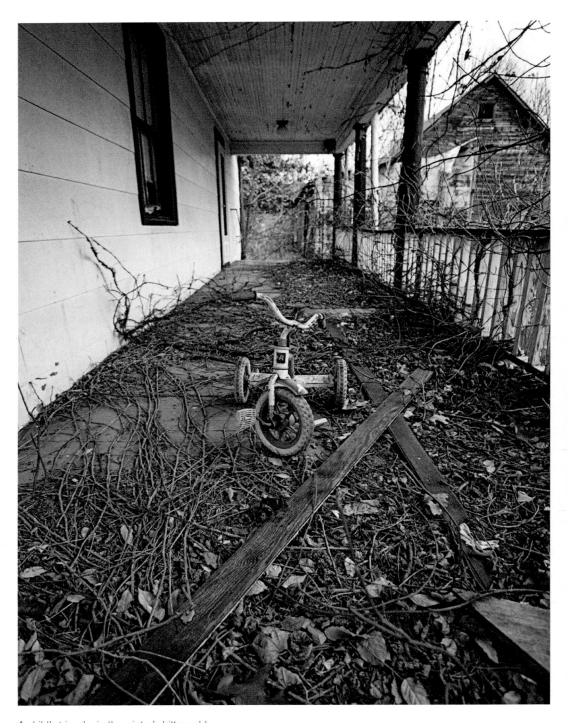

A child's tricycle, in the winter's bitter cold.

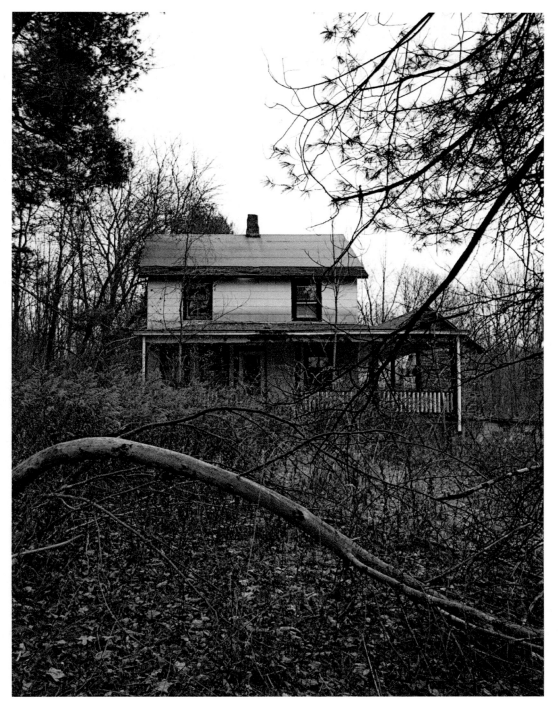

Forgotten home on a remote country road. Upstairs, someone had left behind baby dolls, Barbies, and other various toys.

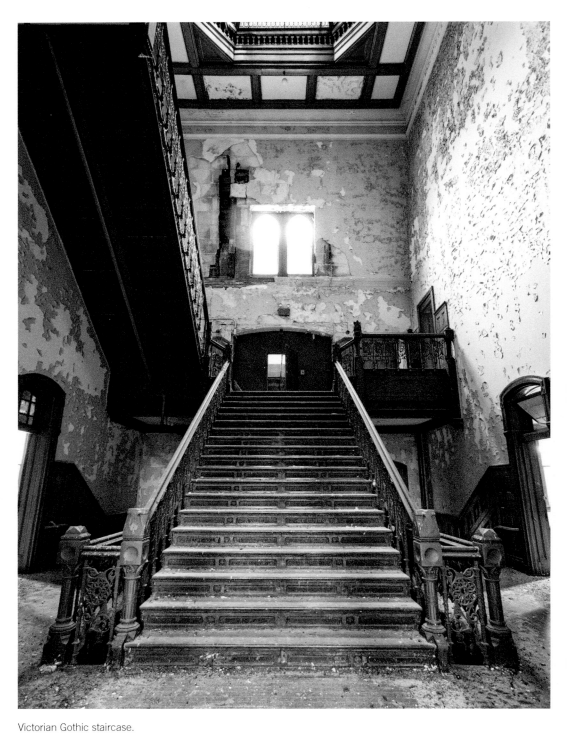

Victorian Gothic staircase.

In the years that followed, when I would pass old homes, factories and even hospitals that were shuttered, I would find myself gazing at them just long enough to catch myself and change the thought. That worked until my teenage years, until I was fifteen.

In a time before the internet could produce the answer to any question in less time than a cameraman can say "cheese," I had no idea just how many abandoned buildings existed around me or in my home state. I could not have dreamed of the splendid artifacts from a former time left behind within these buildings. New York State is home to many cities that expanded and prospered during and after the Industrial Revolution. Economic shifts and manufacturing declines have, however, left many rural towns frozen in time. What were once grand resorts, robust with laughter and life, now are shuttered and silent relics—a place where generations of families spent vacations, deep in the Adirondacks and other mountainous areas of the state. These are now ghost towns, with crumbling buildings lining the dusty streets. Now, picture yourself in contemporary New York City, surrounded by millions of people congregated in the celebration of modernity. The sharp contrast between activity and deterioration in these worlds makes them seem entirely distant from one another. On the contrary, often hidden in the sprawling sea of urban development, sit windows into the past—snapshots of an era come and gone. From hospitals to theaters, churches to homes, no matter where your feet hit the ground in New York State, you will encounter beautiful decay.

It is my hope to share with you a window onto a world not seen by most of society. Join me though the following images to see the traces of lives, left behind doors that time has nailed shut, and to find the beauty in the artful decay and craftsmanship these palaces hold.

ABANDONED NEW YORK:
THE FORGOTTEN BEAUTIES

N ew York has seen centuries of growth, decline, and rebirth. From a land inhabited by Native American tribes, to the Dutch colony of New Amsterdam on the southern tip of the island of Manhattan, the birth of the Erie Canal, to the birth of modern New York City, change is the common denominator and the only constant of history. For those of us accustomed to the pace of urban life, we are all too familiar with the experience of forever being in a rush. What can a boarded-up, dusty-old building tell you that you can't find on Google?

The German word *zeitgeist* translates roughly in English to "spirit of the time." It is hard for this writer to think of a clearer look into the zeitgeist of the past than to examine the possessions left behind by the last inhabitants of a factory, home, or hospital. This could be a factory closed in 1968, where perched on a window sill is a newspaper, whose headline announces the assassination of JFK, or a handwritten letter from 1890 in a state hospital, discussing the delivery of local coal. A sense of connection is established between the individual, the building, and the historical moment. It is a real-time occurrence that is not experienced by merely reading about a place or an event in a book or on the internet—it's truly tactile. This idea, that photography, history, and the present can come together in places stuck in the past, is not always easy to put into words. Exploring, as a term referring to visiting and photographing these places, is synonymous with experience. It is an experience to touch and see nineteenth-century New York inside a shuttered place, while simultaneously looking out from that building to see the streets and people of the present day.

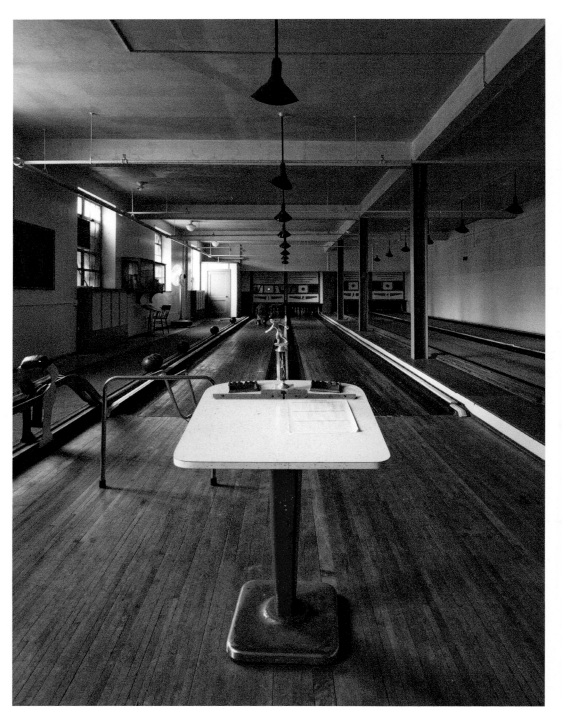

Bowling alley in a 1930s State School.

For those who explore the traces of the past, New York is rich territory. The state has dozens of medical and psychiatric hospitals that shuttered over the last fifty or so years. These establishments were thoughtfully constructed with careful attention to light, airflow, and sound for the patients who inhabited them, often individuals needing long-term care for mental illness or infectious diseases. They represent the lofty beliefs of medical pioneers in nineteenth-century America, of more benevolent views toward the poor, who generally inhabited public institutions. These now-shuttered buildings stand as testaments to care and dignity even in their state of ruin. They are elegant structures situated on rolling grounds with picturesque views meant to invigorate the body and spirit. They show modern public buildings, by comparison, to be wanting in providing fresh air and a way of living that is more generous to their patients' humanity. Now, these once bustling facilities—some long since erased from the memory of local inhabitants—have been reclaimed by Mother Nature.

Growing numbers of immigrants arriving at Ellis Island led to an increased demand for mental health, as the population of New York City expanded. In 1841, poor patients were moved to the newly opened New York City Lunatic Asylum (a public city facility), located on what is now called Roosevelt Island. Patients who could afford private treatment remained at Bloomingdale. In 1836, a legal resolution authorized the establishment of a state asylum at Utica. This asylum opened its doors in 1843 and received the most "incurable cases" from county poorhouses. It was the first state-run facility in New York State to provide care and treatment for the mentally ill.

Walking through these buildings now, the explorer sees buildings that are quite different from what their nineteenth-century founders intended for their residents. Paint is peeling and chipped in the hallways and patient rooms because of neglect and exposure. Personal belongings, as well as old medical supplies, can be found in many of the abandoned buildings. It's curious to think that the administrators and staff of institutions so large, so busy, could simply walk away, leaving so much behind. Some of these institutions have long vacated their premises and the sites no longer function for their past purpose; others are struggling to survive, leaving some buildings empty on their campuses.

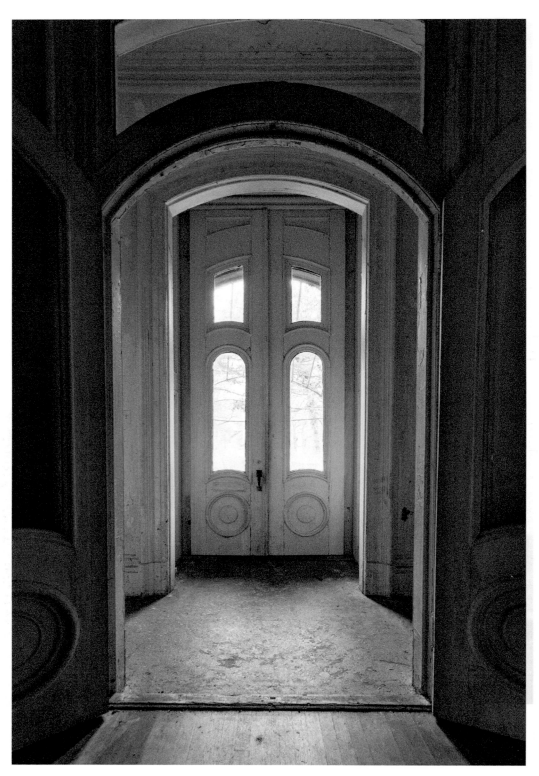

Beautiful hand-carved woodwork in a doctor's house.

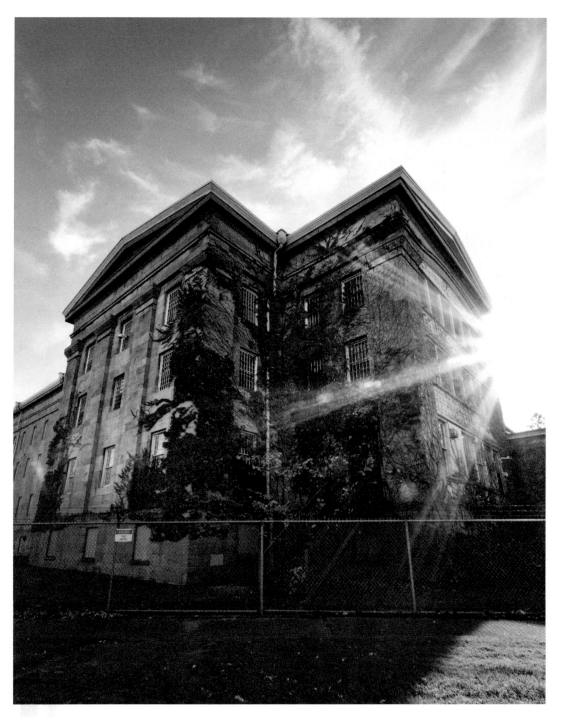

Ivy climbs the main building of the former New York State Lunatic Asylum in Utica.

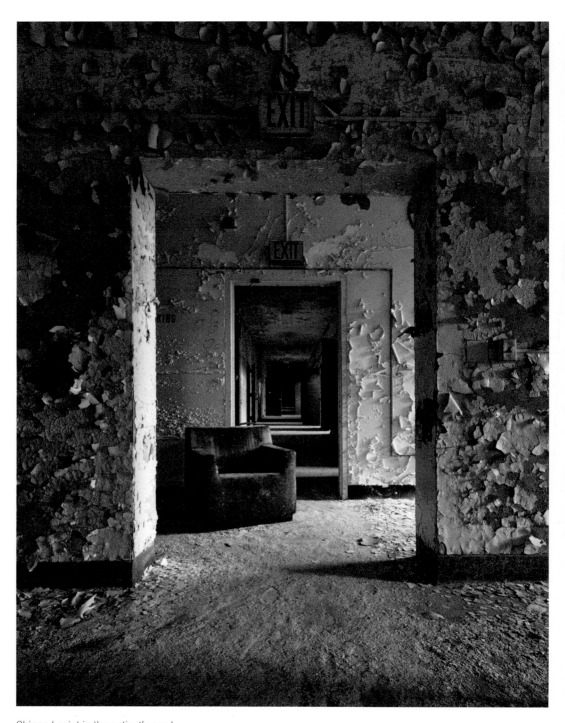

Chipped paint in the patient's ward.

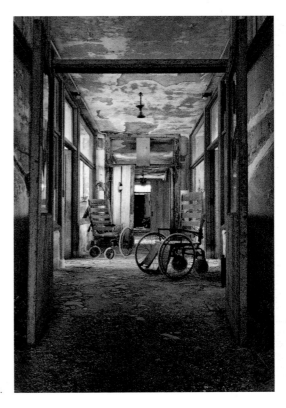
Old wooden wheelchairs.

The first two sanatoriums built in North America were in New York. The first was the Adirondack Cottage Sanitarium, built in 1885. They were constructed primarily to treat people suffering from a long-term illness, most typically tuberculosis. Sanatoriums were constructed in remote areas, as resort-like complexes, where the ill were prescribed treatments of clean, cold mountain air—thought to be the best remedy for lung disease. By the 1960s, with the introduction of antibiotic treatments, tuberculosis was no longer a large concern as it had once been, due to medical advances. Many sanatoriums were repurposed as general hospitals, while others were demolished. New York is fortunate in having a few that still exist. Even in states of disrepair, these edifices remain a stunning reminder of skilled craftsmanship, rare to our time.

Loomis Sanitarium, located in Liberty, New York, was the second sanitarium to be built in the country. Founded by Alfred Lebbeus Loomis, it was a smaller quarantine hospital, which served over 230 patients at a time. As a physician specializing in respiratory illness, Loomis advocated proper nutrition and exercise as cures for tubercular patients. Sadly, he died eighteen months before the hospital opened in 1896, after decades of battling tuberculosis.

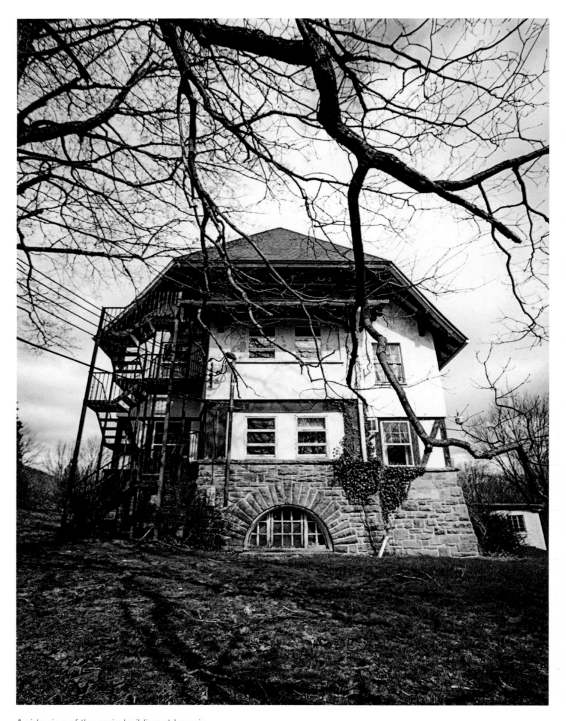

A side view of the main building at Loomis.

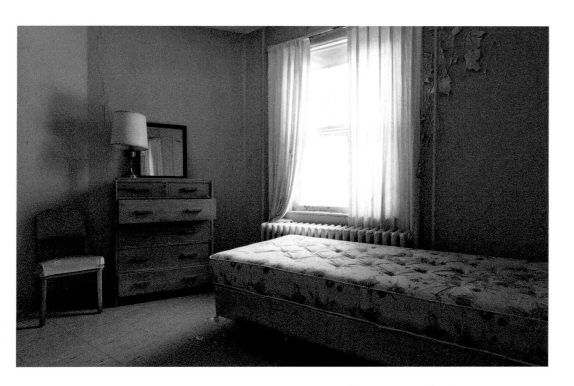

Above: Rooms appear intact, as if patients might come back.

Right: TVs and books left behind in a patient's room.

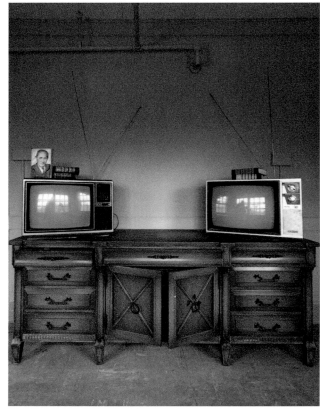

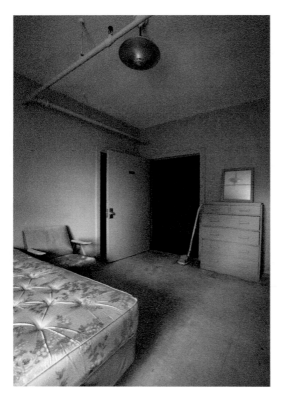

Furniture and a vacuum from another era.

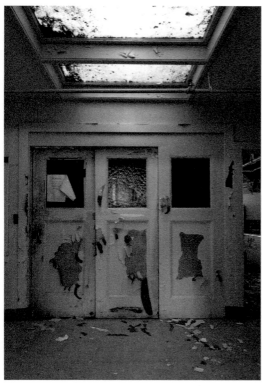

A service elevator on the top floor. Natural light
pours in from the skylight above.

The Organ House was constructed in 1859 as the home of an officer who served in the Civil War. In 1915, this Gothic-style house was converted into a privately licensed psychiatric hospital and sanatorium, one of the first in the country. At the time, it was believed that patients could be cured through intensive talk therapy and nutrition. Patients received other therapies through recreational activities such as golf, swimming, skiing, and painting. For decades, it was the country's most prestigious psychiatric rehabilitation home. Though, the suicide of a patient, who cut her own throat while under care, did not help its public image. The once exclusive and high-end hospital closed its doors in 1999 and currently sits idle and forgotten.

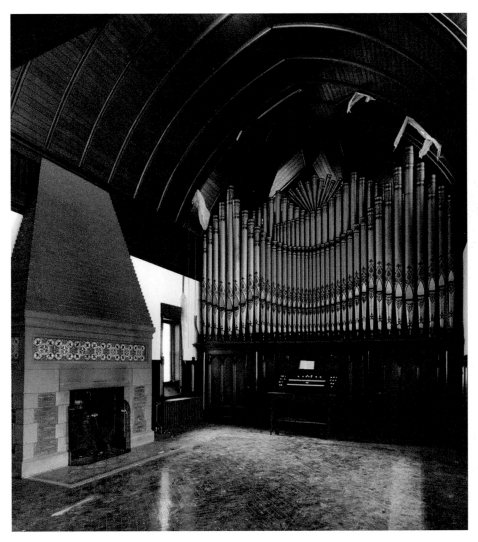

At first glance, you would never imagine stumbling across a room with an organ of this scale.

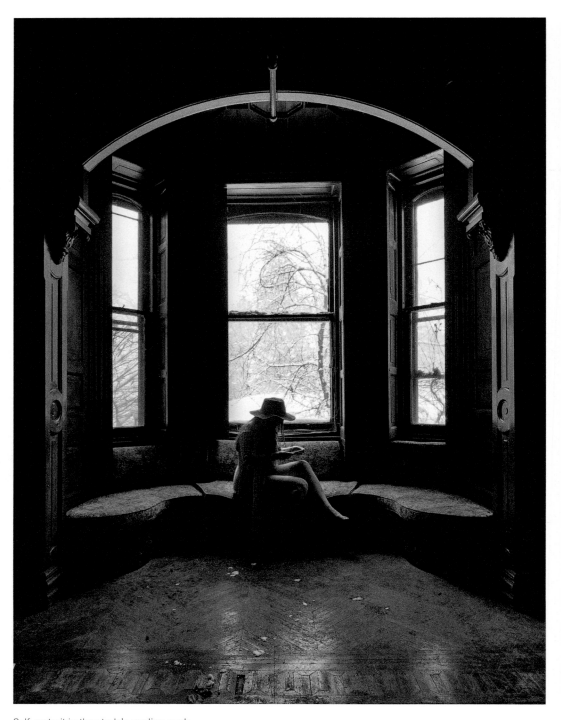

Self-portrait in the study's reading nook.

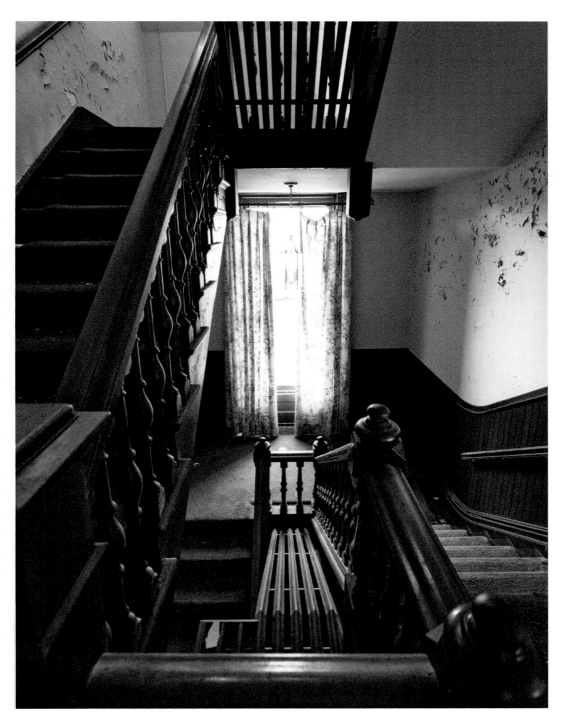

The main staircase.

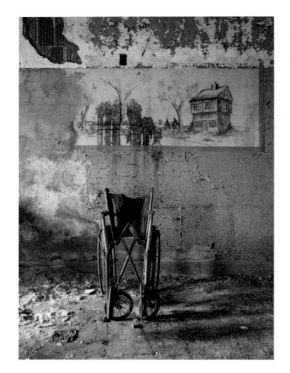 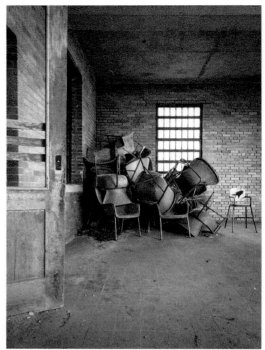

Above left: A lonely wheelchair in a beautifully decaying dayroom, which is home to a man with nowhere to go. Many of the common areas of this older building in the complex have skillfully painted murals.

Above right: Open-air dayroom with colorful chairs.

Due to the push for deinstitutionalized care, the growth in pharmacological treat-ment and budget cuts, psychiatric institutions across the United States began to close in the 1960s. Long Island is home to many former "farm colonies," such as Kings Park Psychiatric Center, Edgewood State Hospital, and Pilgrim State Psychiatric Center. Farm colonies were originally experimental parcels of land purchased by the City of New York to house the most chronically ill individuals from the city asylums. They grew quickly as the colonies were touted as a successful alternative to city asylums. Patients lived in modest cottages and farmed the land to promote their independence. With the passage of the State Care Act of 1890, New York State assumed responsibility to operate the colonies and turned them into state hospitals.

The "Farm Colony State Hospital" opened in 1926 with only thirty-two patients on order of transfer from the Brooklyn State Hospital. By 1959, it housed 7,000 patients. The facilities were designed to house and rehabilitate patients deemed incapable to function on their own. The hospital complex is still functioning, but with very limited operation. Many of the buildings on the property sit vacant and decaying, while others have become home to current patients.

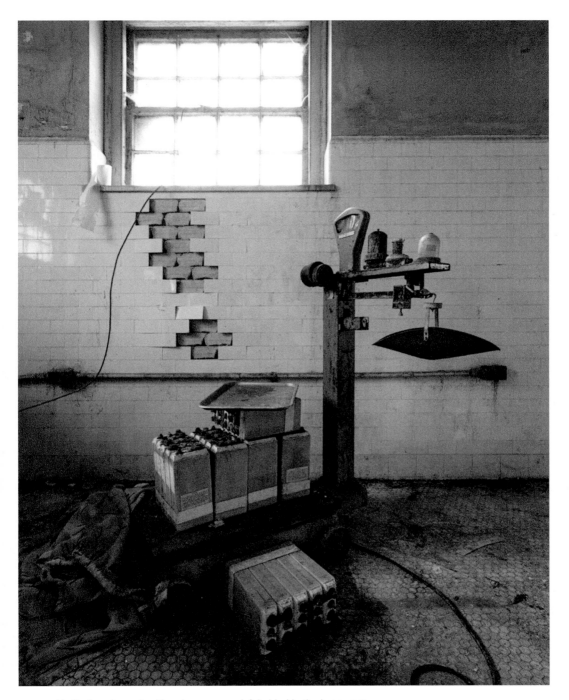

Medical equipment, with unknown uses, left behind in the basement.

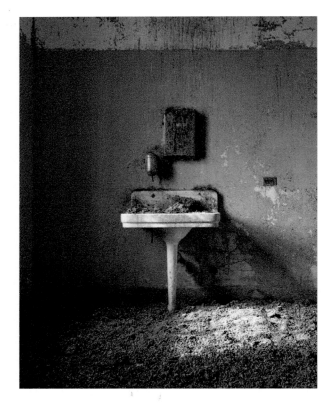

Pigeon droppings cover the floors and sinks on the top floor. In the hallways, it is inches thick from years of accumulation, and the smell makes it impossible to explore this floor during the warmer months. The rest of the building smells of stale air, mold, and decaying animals.

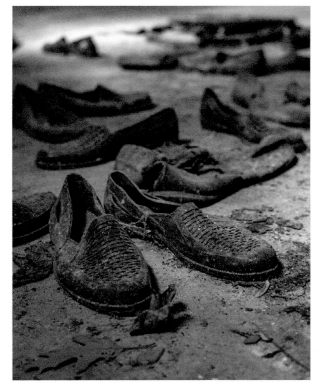

Patient shoes in the basement fallout shelter.

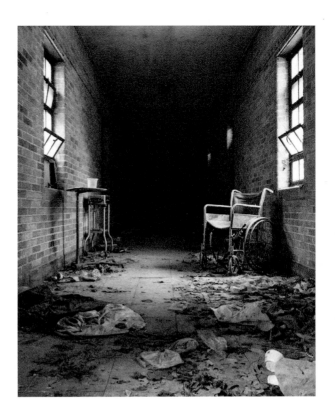

An above-ground tunnel leading to a semi-active building.

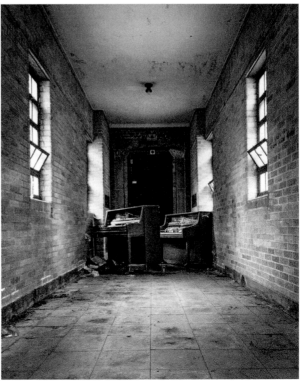

The doorway leading into the semi-abandoned building, partially obstructed by two pianos.

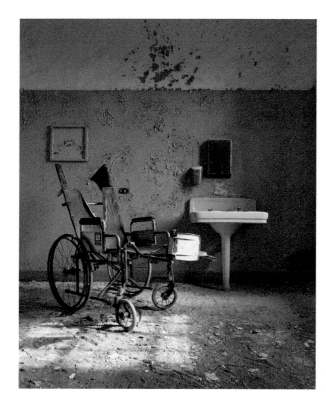

Another wheelchair long forgotten in a patient's room.

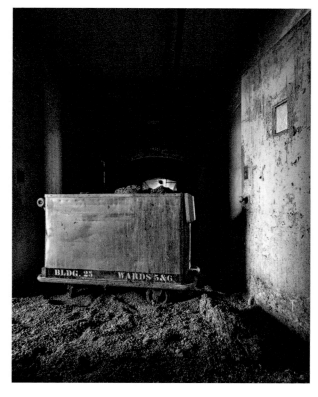

An old food cart amid pigeon droppings.

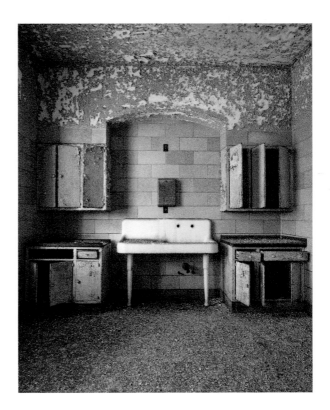

Mellow yellow medical room.

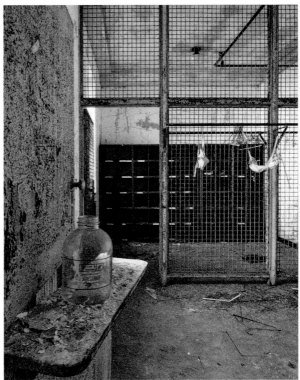

Bras left on rusty clothing hangers.

Hudson River State Hospital for the Insane, in Poughkeepsie, opened in 1867. By the time it received its first patients on October 18, 1871, it had been renamed the Hudson River State Hospital. The main building was designed according to the Kirkbride Plan, named after Dr. Thomas Story Kirkbride of Pennsylvania: a young Quaker physician who changed the shape of mental health care in the nineteenth century. The main building initially housed almost all functions necessary for hospital operations—from administrative offices, patient wards, staff quarters, and kitchens, as well as a theater. The building's south wing housed the male wards and the north wing, the female wards. Construction continued on the main building until 1906, although it was never completed. The campus was equipped with its own power plant and locksmith. A recreation center housed a pool, bowling alley, theater and basketball court. The campus population slowly dwindled during the 1960s and the historic main building was officially shuttered in 2001. Over the years, the buildings have been plagued by arson and vandalism. Its adaptive reuse has been discussed over the years, but unfortunately, there has been little to suggest a real plan for implementation.

Your first time exploring the Hudson River State Hospital can be nerve-racking. You crawl through a window of what appears to be an extension. Then, entering through the window, you see a gaping hole directly in front of you in the floor. You must pass around the hole to the center of the room and then start shooting. On my first exploration, a friend walked toward me and as he came closer, the floor started to give way. After several more trips here, I finally mustered up the courage to climb back into the window for another chance to glimpse its beauty.

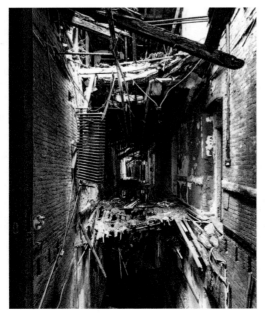

This collapsing hallway was the result of a 2007 fire, which left the majority of this south wing ward unstable and unsafe for entry. This is a view from a third-story doorway. As you explore within the building, you are constantly being turned around and have to switch floors to safely enter further into the ward.

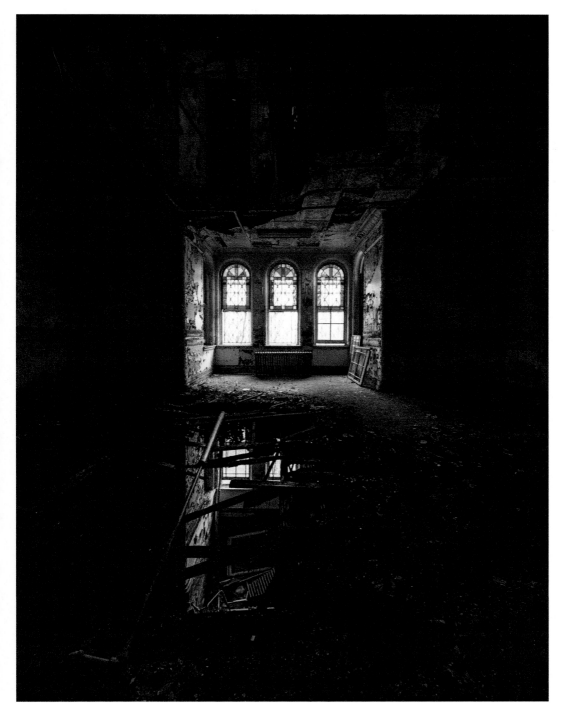

The view behind the vantage point of the previous photo.

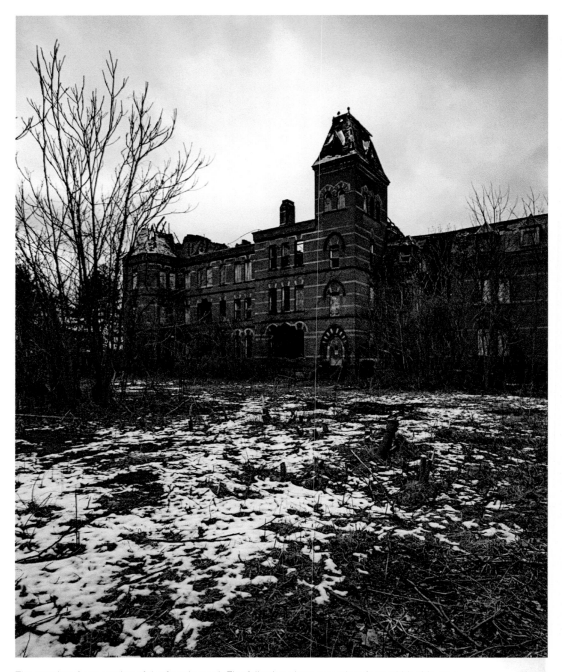

The exterior of one section of the female ward. The following photo was taken from within this area.

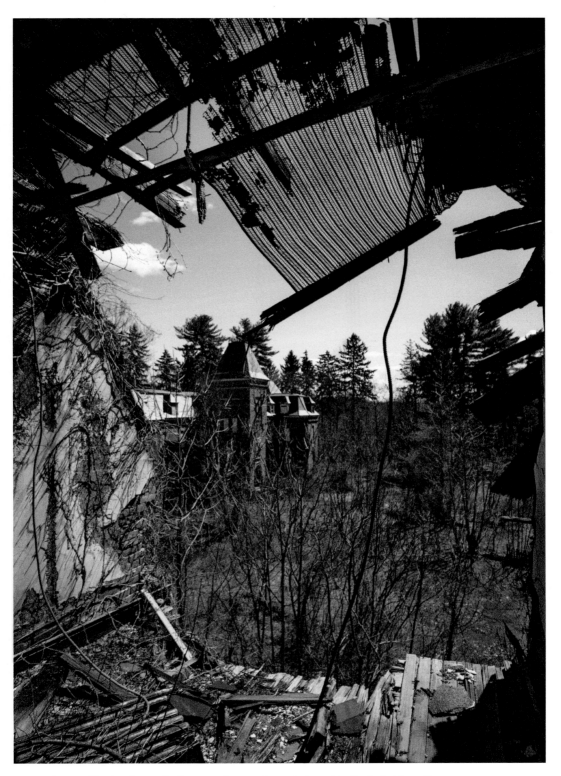

In one of the top-floor patient rooms, whose wall was destroyed by the first of three fires.

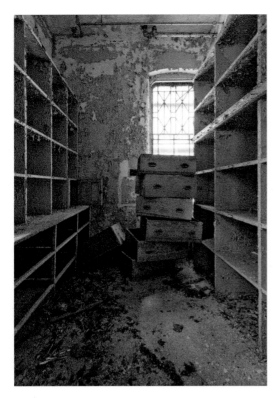

Each drawer was labeled with a name on a piece of tape—one drawer for each patient's personal belongings.

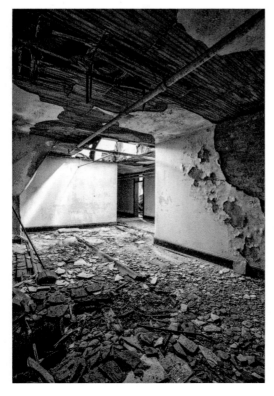

Rooms along this hallway are missing portions of the ceiling; floors are missing in others.

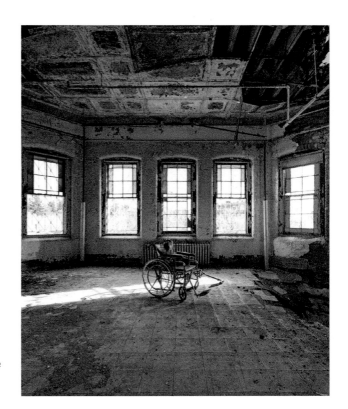

Beautiful stained-glass windows. The floor at the right side of the room is collapsing and is nearly gone.

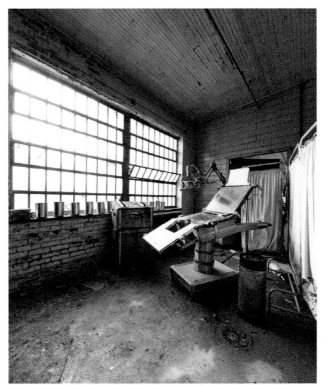

The majority of the buildings still hold old medical equipment, furniture, and supplies. This hallway includes items found in the surrounding rooms.

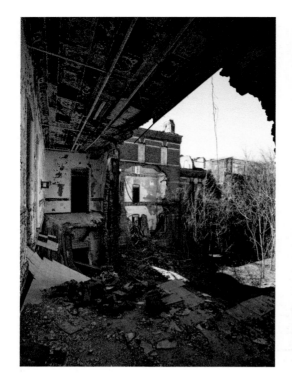 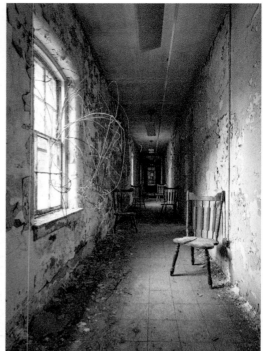

Above left: The back side of the building is crumbling, with debris from the exterior walls fallen to the ground below.

Above right: An endless hallway with ghostly chairs.

Construction on the "Wheelchair State Asylum for the Insane" began in 1870 and took twenty years to complete. The hospital's main building closed in 1974 and remained vacant until 2008. After a successful lawsuit by the county preservation coalition, the severely damaged portions of the building were repaired. Further repairs and redevelopment construction began in 2013. The administration building and a number of the wards now serve as a hotel. As construction continues, this Kirkbride will be restored to its former beauty and enjoyed by new generations.

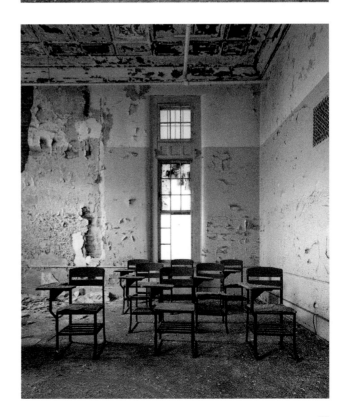

While waiting for the sun to rise, we wandered through the wings, trying to locate the rooms we wanted to photograph. We pulled the chairs out of the patient rooms and placed them as they appear here. After taking our photos, we returned the wheelchairs to the rooms before making our way out of the hospital. This site is not technically abandoned, and workers can access it at any point.

Classroom in the female ward.

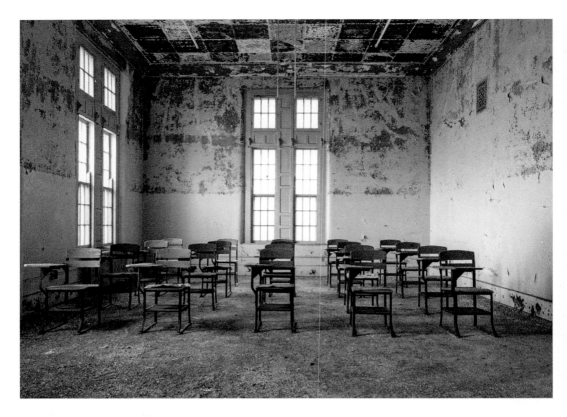

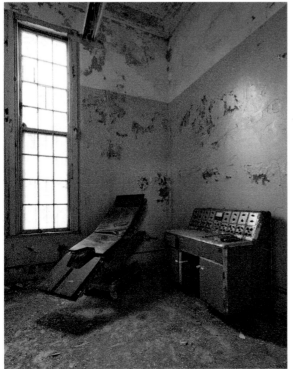

Above: Classroom in the male ward.

Left: An electroencephalograph, which detects brainwaves, which was from Kings Park Psychiatric Center.

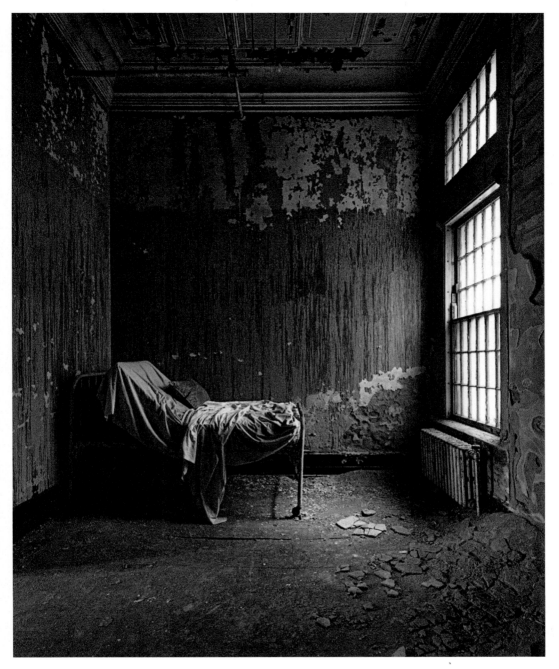

A patient room whose walls are covered in smoke from a previous fire.

Rockland Psychiatric Center, formerly Rockland State Hospital, was established in 1927 in Orangeburg, New York, to alleviate the overcrowding at institutions in New York City. The hospital had 5,768 beds when it first opened. By its peak in 1959, there were over 9,000 residents and a staff of 2,000. The grounds were equipped with a bowling alley, power plant, theater, a farm, and shops. It even had industrial shops, all staffed by patients, that manufactured mattresses, furniture, and brooms. In the 1960s, the development of antipsychotic drugs and vocational therapy aided patients in living independently, outside the hospital. The center began operating as an outpatient facility in the 1970s and since 1999, it has housed less than 600 patients. On February 1, 2017, Rockland sold sixty acres of land to JPMorgan Chase. And by February 2018, the abandoned buildings had been demolished to build a 150,000-square-foot data center.

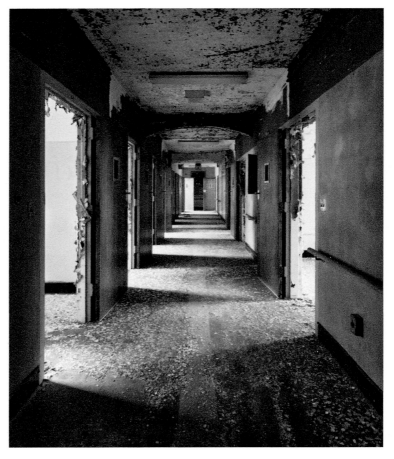

Chipped paint hangs from the hallway's walls and ceilings of what once housed the general geriatric unit, psychogeriatric unit, statewide deafness unit, and the supportive rehabilitation unit.

Right: To the left is the nurse's station, which juts out to allow observation of the patient rooms and the seclusion room.

Below: Rockland's theater and bowling alley were always a memorable part of exploring there. To get to building 40, you went from building to building through a series of tunnels. The theater was located on the main floor, and the bowling alley was underneath. To access the bowling alley, you crawled underneath the theater stage. As you made your way down a rickety ladder, you arrived on top of several bowling machines. It felt as if you'd been beamed down into the 1960s or 70s.

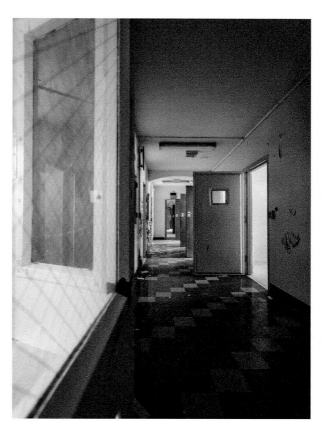

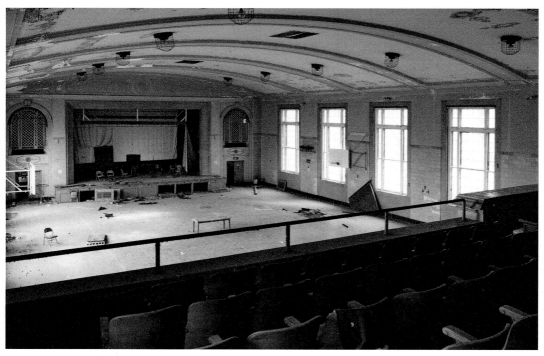

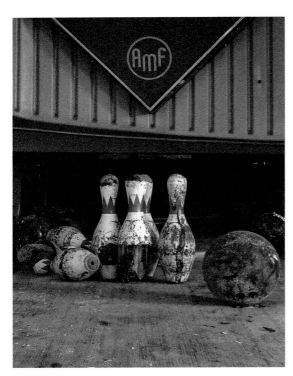

Left: Bowling pins still set up with a ball placed for a perfect photo, in one of the four bowling lanes.

Below: The bowling shoes and bags of former patients. Paper score sheets were also left behind.

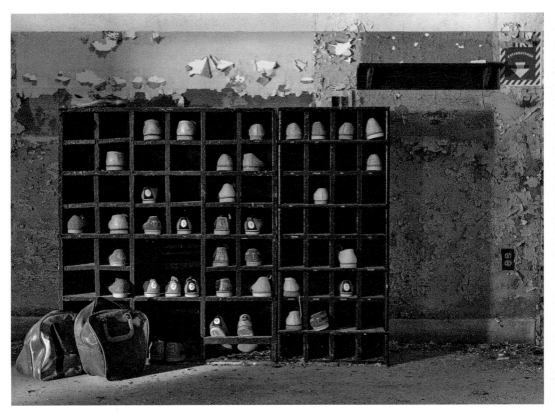

The "Hospital on the Seaside" was built in 1905 to treat tuberculosis. Constructed on a hilltop with a view of the sea, it was designed to prevent depression and aid patients suffering from mental illness. There are truly stunning examples of early twentieth-century craftsmanship in these buildings. Each floor contains a spacious and airy layout with heavy, handmade wooden doors that open onto glassed-in porches.

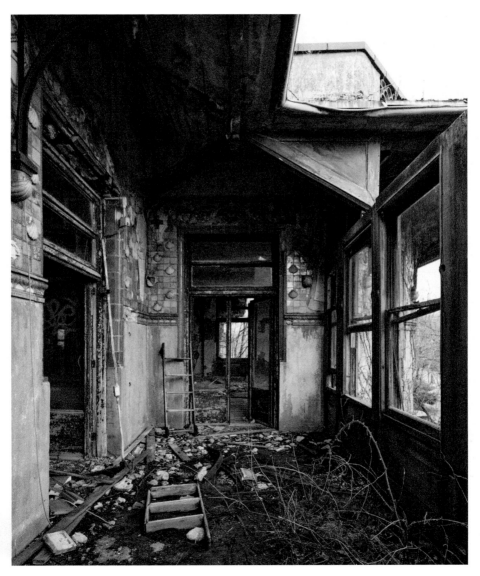

The top floor porch walls in the four wards are adorned with seashells and tiled murals of doctors treating patients. The floors are covered by moss; and some pieces of this roof, as in some of the other wards, are falling away.

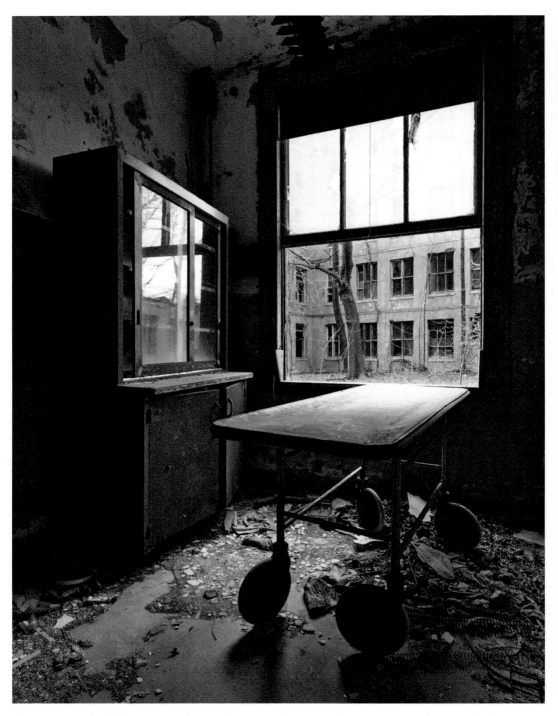

A gurney and medical cabinet, which held tongue depressors, dressing packs, hypodermic needles, and catheters.

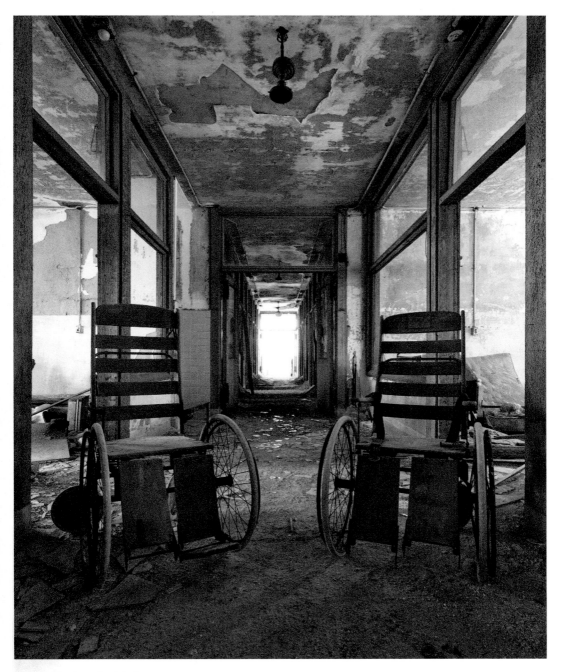

Wooden wheelchairs.

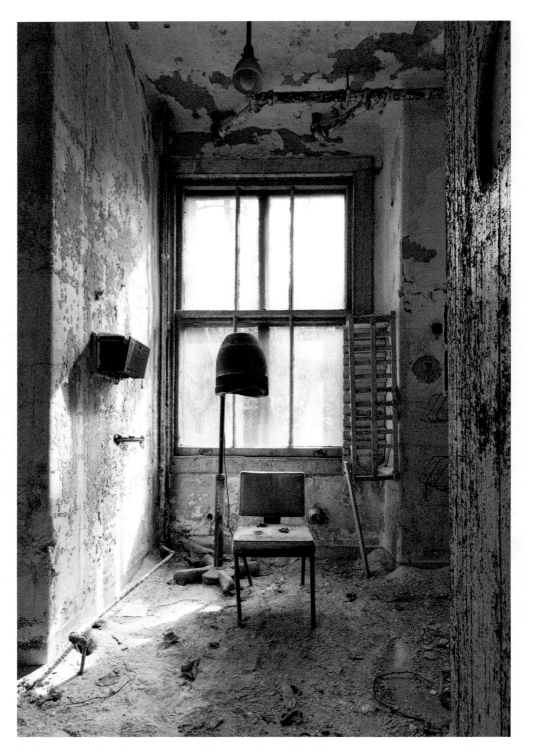

Unlike some hospitals that have designated salons, there is hair salon equipment in various areas across two wards at this site.

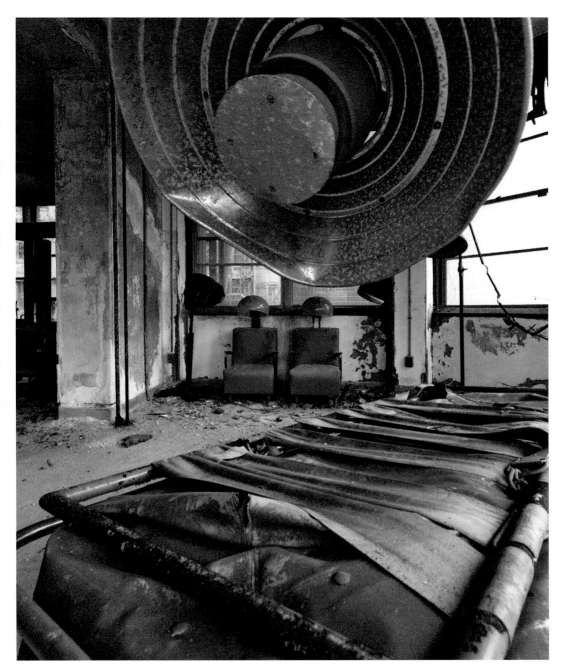

Salon chairs and medical equipment have been moved from different wards to stage photographs featuring items from various time periods. Moving these heavy items is difficult, especially trying to move them quietly, since the surrounding hospital buildings are all actively used.

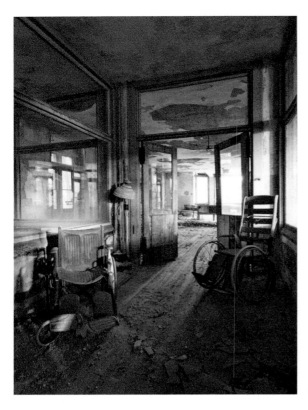

Hallway leading to a dayroom.

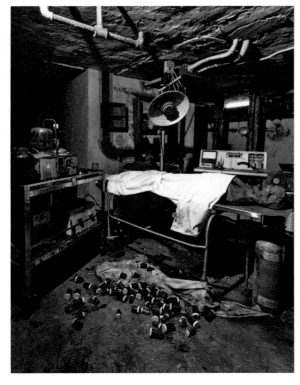

Medical examination equipment in the basement, complete with a fake cadaver.

The Harlem Valley State Hospital in Dover opened in 1924 as a psychiatric hospital. This land was originally a local prison, the Wingdale Prison, but it was repurposed as a state hospital after complaints from local residents. The property is almost 900 acres and once had over eighty buildings, 5,000 patients, and more than 5,000 employees. The facilities included a bowling alley, baseball field, golf course, bakery, and dairy farm. Later named the Harlem Valley Psychiatric Center, the hospital pioneered advances in modern psychiatric treatment. It was the first facility in the United States to perform insulin shock therapy in 1937. Although this treatment modality fell out of favor with the advent of psychotropic medication in the 1950s, it was viewed with hope at a time when medicine offered little in the way of chemical interventions. Once Thorazine was introduced in 1955, the hospital population began to decline. By 1994, Harlem Valley was shuttered and consolidated into the nearby Hudson River Psychiatric Center. In 2013, the abandoned hospital was purchased, with the intent to give new life to the buildings as a college.

Exploring Harlem Valley State Hospital took some time because of the stories of the tunnel system. Harlem Valley State Hospital is known for having some of the worst hospital tunnels. They were a slippery, wet, and upward climbing challenge. Not only are they flooded, but they are confusing to navigate. After entering through one tunnel, you would wind up where you started. Try another tunnel and end up at the very same place. Once you finally figure out that maze of tunnels, you will find one that leads to the old medical building. Nicknamed "Hell's Tunnel," it's much narrower in diameter. Therefore, you are forced to squat with your camera bag in front of you, trying to avoid hitting the pipes above your head. At one point, you must climb a ladder to continue through the system of tunnels. The tunnel widens incrementally, providing a little more space—but while there is minor relief from the cramping, there is a significant increase in steepness as you begin the journey uphill. After spending ten hours exploring only half of the buildings on the campus, I'm not sure this is a destination worth revisiting.

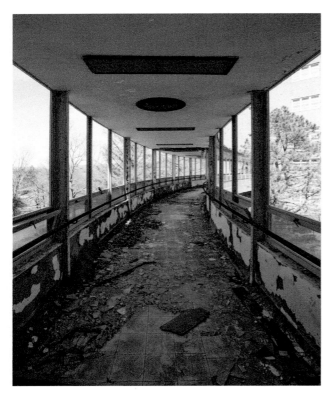

Above-ground connector from the older medical building to the newer one.

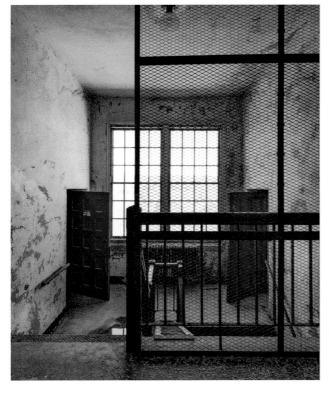

The "Red Door Building," as explorers call it, was originally constructed for the Wingdale Prison. As you wander through the building and its hallways, you're reminded of jail cell layouts.

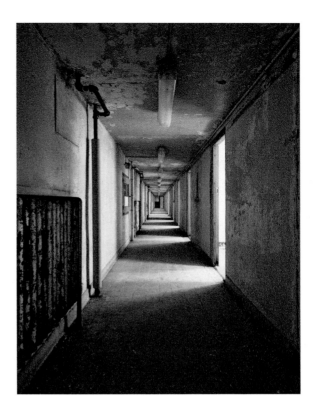

Hallway in the Red Door Building.

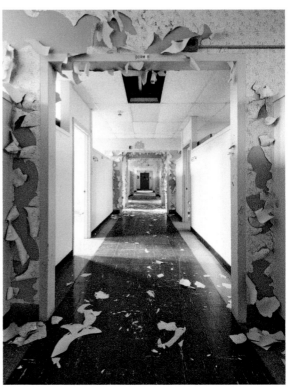

Peeling paint in Dorm B.

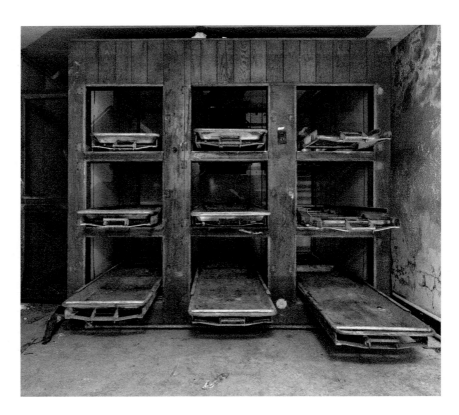

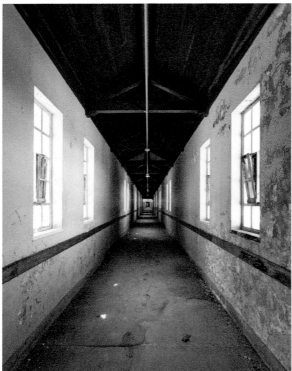

Above: The morgue, located in the basement of the older medical building.

Left: One of the colorful hallways, leading to the cafeteria.

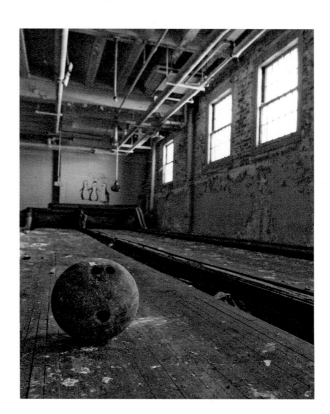

The bowling alley, located in a semi-flooded basement.

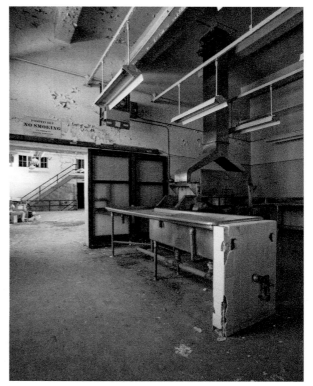

A hand-painted sign that reads "Positively no smoking by order of the senior director" remains pasted in the kitchen.

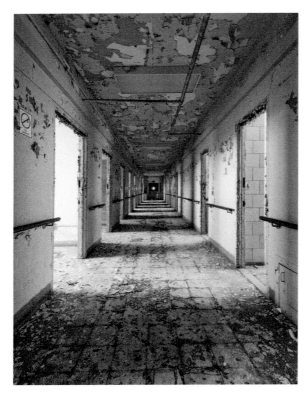

The floors are covered in chipped paint, which crunch and crack with each step.

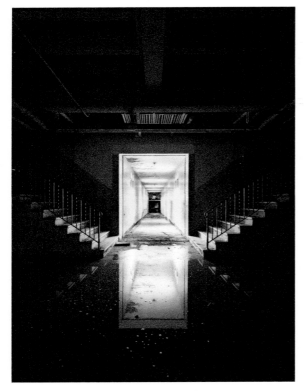

This facility's bottom floors are flooded with water, only an inch in some areas and up to ankle deep in others.

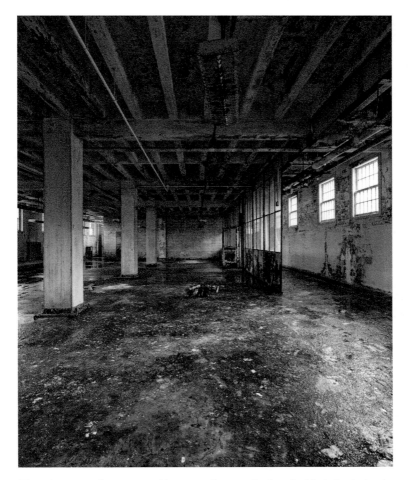

These basement floors covered in green slime can be found while trying to locate the utility tunnels. You will need to travel underground through the campus to avoid being caught by security.

The "Faces Hospital" opened in 1889 as a farm colony hospital. What began as an experimental city settlement in the wilderness of pine and oak scrub grew to a successful psychiatric hospital, which operated for over 107 years. The first group of male patients, on order of transfer from Wards Island in Manhattan, cleared the land and constructed the buildings, roads, and even the furnishings in the wards. The men were described as quiet and chronic cases. In just a few years, women patients arrived at the colony. Individuals sewed their own clothes, looked after the animals, and farmed crops as a part of their therapy. About 10,000 patients were housed on the property at its peak in the mid-1950s. The institution's population started to dwindle in the 1970s and it ultimately closed its doors in the fall of 1996.

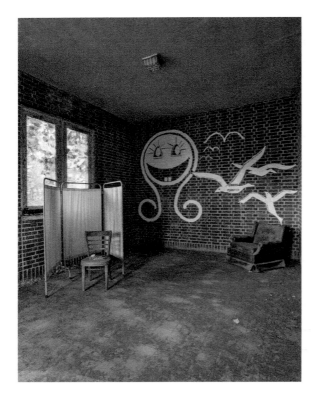

Left: One of four murals painted in a few of the dayrooms. The red ink on the seagull reads, "Smoking permitted."

Below: Hooray for exercise!

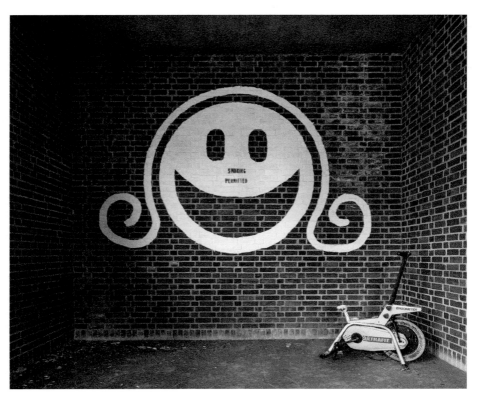

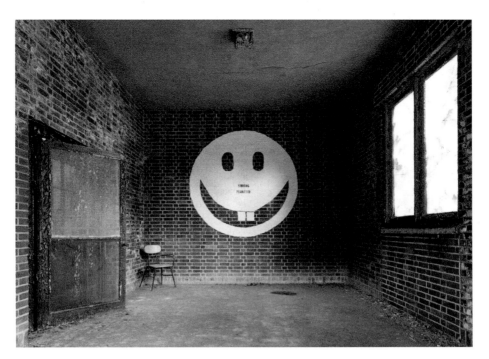

Ivy covers the exterior of this dayroom, casting a green hue all around.

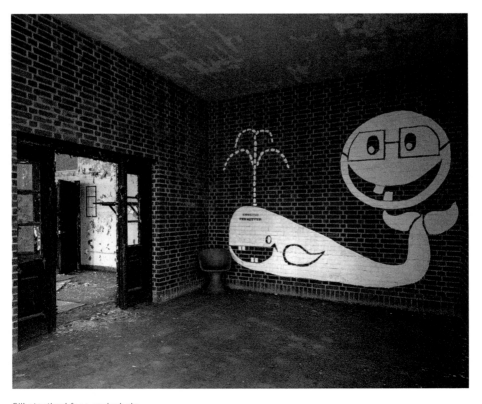

Silly-toothed face and whale.

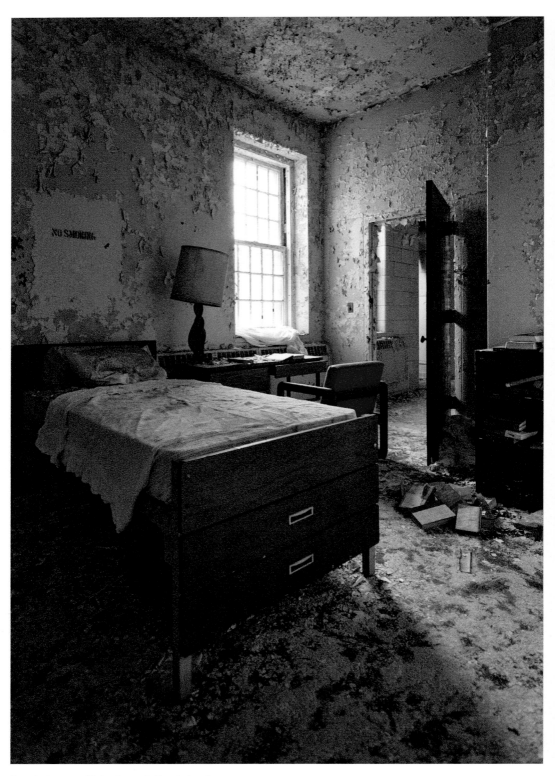

A patient room with books and other belongings.

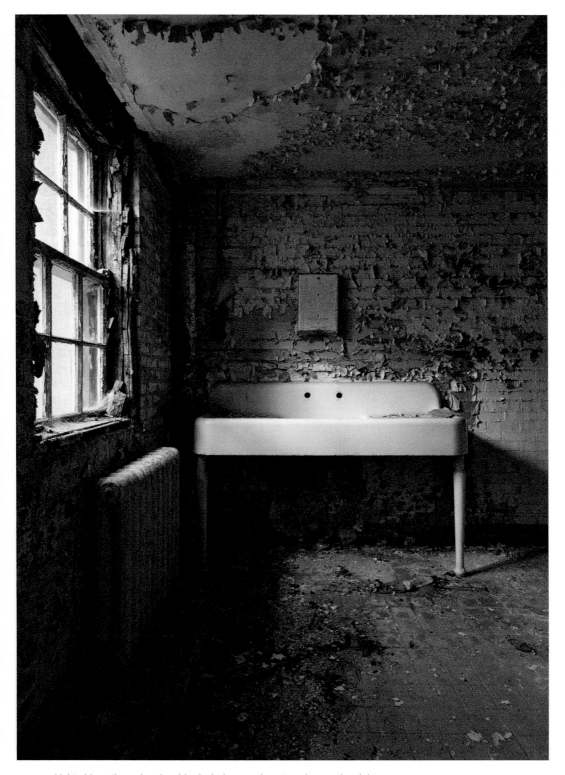

Light shines through cobwebbed windows and casts a glow on the sink.

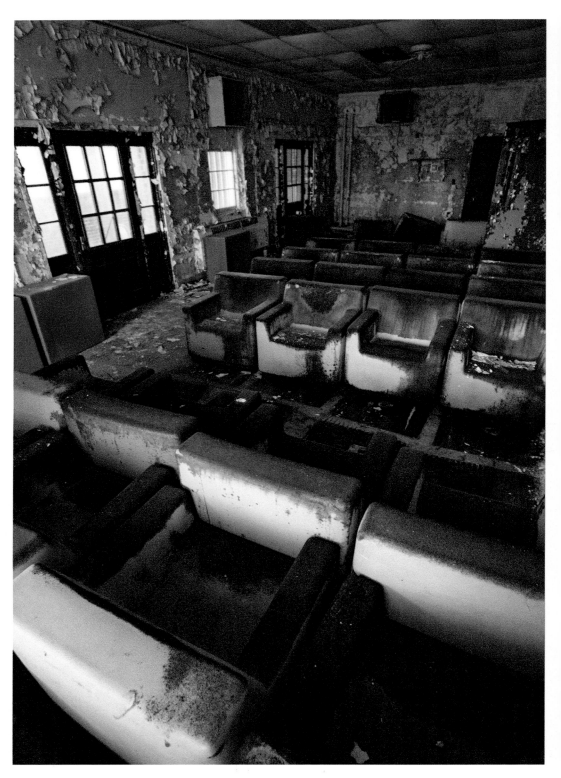

Rainbow-colored plastic patient chairs, covered in what seems to be black tar.

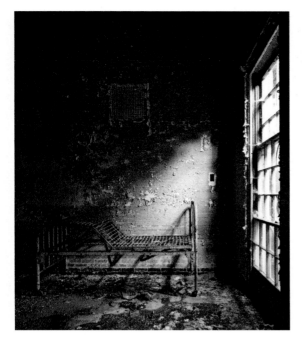

Above left: Natural light shining beautifully down.

Above right: Weathered and worn.

New York is also home to a staggering number of abandoned homes, scattered from Buffalo and the Catskills to New York City, even all the way to Long Island. Once filled with families, these houses are now vacant and largely long forgotten. Many are strewn with personal belongings and all invite the same question: Why the sudden flight? Why did their residents leave behind a lifetime of belongings and turn the key in the lock, never to return? Family photos are scattered on the floor, even children's toys are left on a shelf. Some houses were inhabited by an elderly resident, who passed away with no kin to claim the property or who were too estranged from family for inheritance to matter. Some, once occupied by a hoarder, are filled from floor to ceiling; others are nearly bare.

Nicknamed the Great Gatsby house, after F. Scott Fitzgerald's novel, this house sits on a piece of land in Kings Point. Compared to the glossier, newer houses on its property, the old main house—which is photographed below, with its chipped paint and elegant wallpaper—has a unique charm.

This house was seized by the local authorities and the owners were arrested for animal cruelty. There are no traces of the animals that are said to have been rescued. There is no fur and no droppings—only a single couch that appeared to be a scratching post for cats.

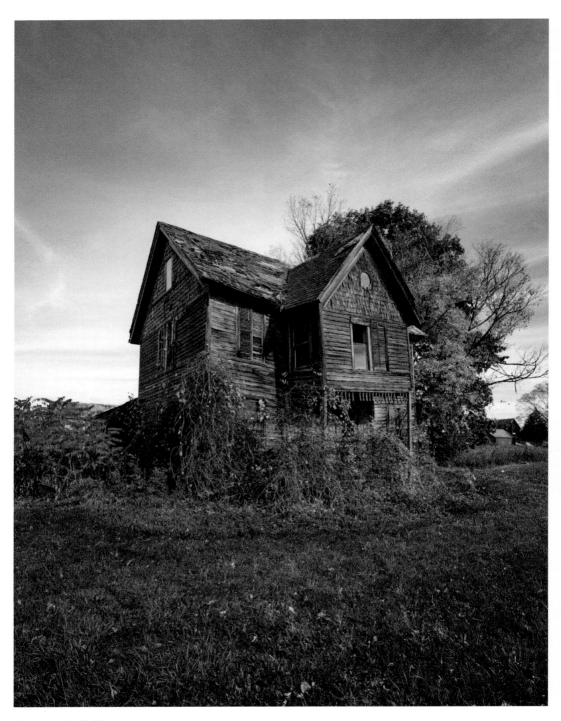

On the way to Buffalo.

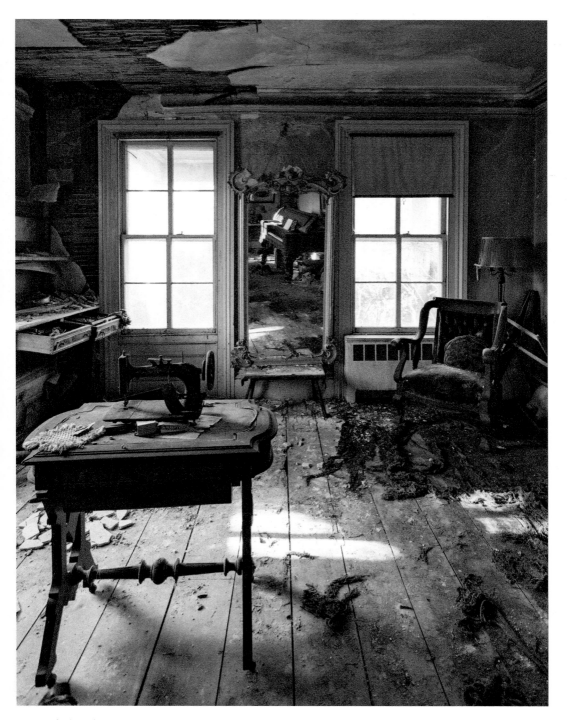

Antique furniture in a farmhouse from the 1800s.

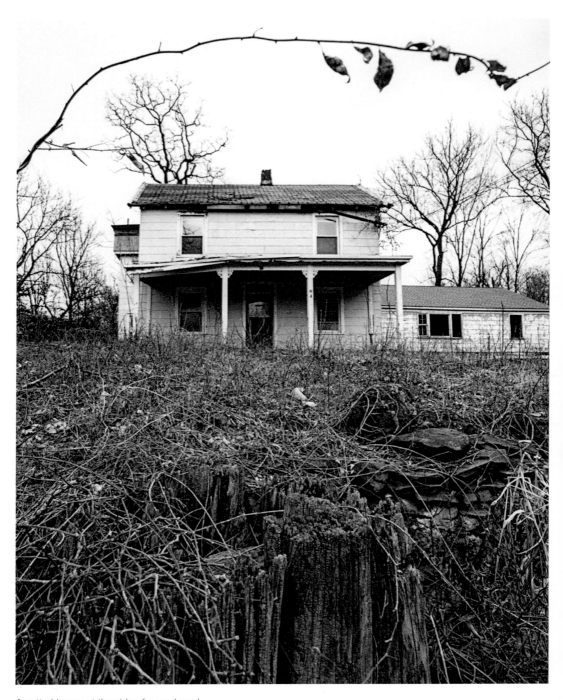

A gutted house at the side of a rural road.

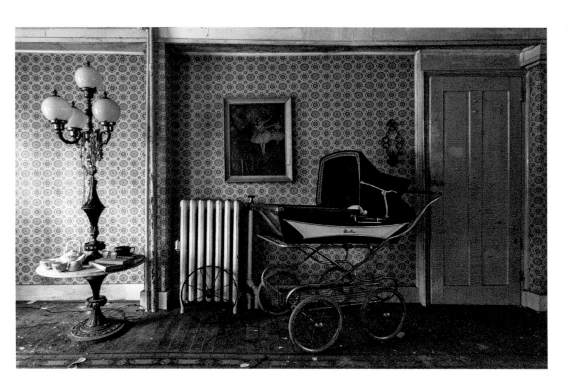

Above: An elegant past of the baby carriage house.

Right: A house boarded and abandoned but filled with belongings. There is still power on the bottom floor to deter trespassers and squatters.

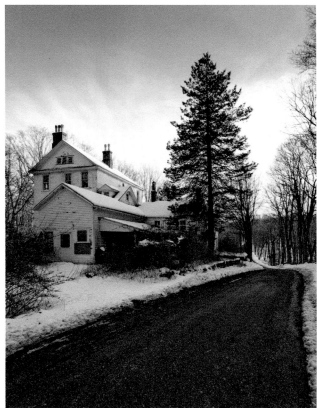

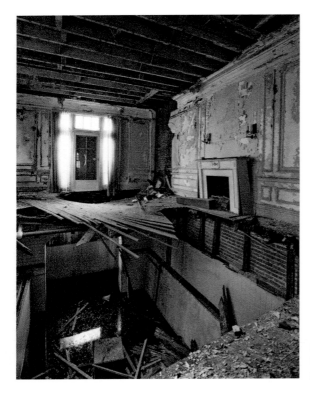

After years of neglect and the water in the basement pool caused the living room floor of "The Collapsing Mansion" to cave in.

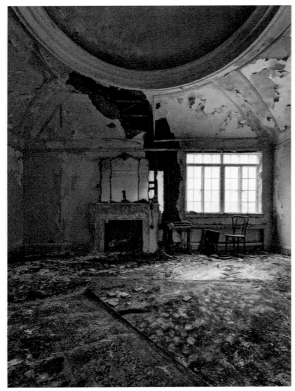

Beauty, elegance, and decay.

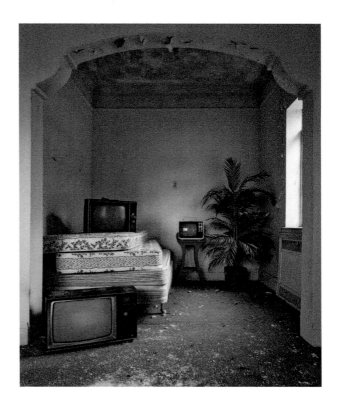

Too many forgotten TVs.

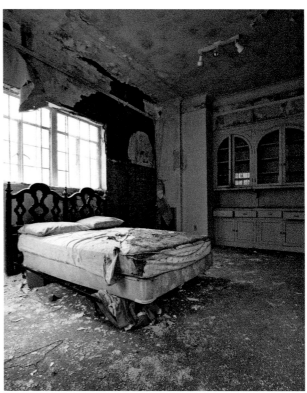

A cozy room to rest your tired head.

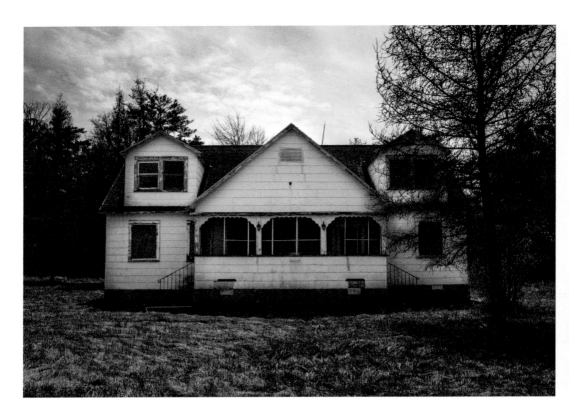

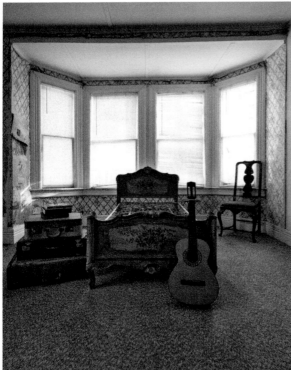

Above: The tiniest details on the porch add such charm.

Left: The snow outside illuminates the room.

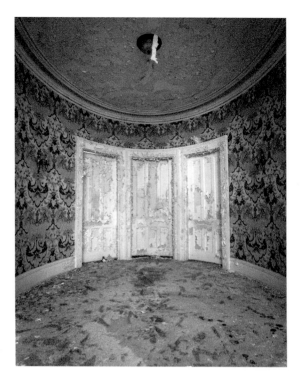

Three curved doors. The right and left doors each lead to a bedroom, and the middle leads to a bathroom with elegant black wallpaper.

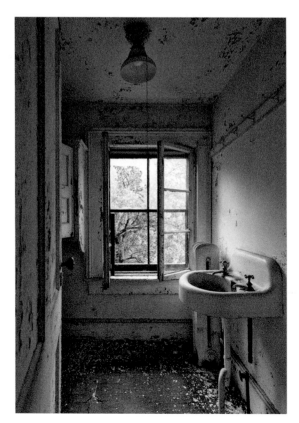

The back end of the old main home appears to be the servants' quarters. It had a private staircase with a few small bedrooms, two bathrooms, and a laundry room.

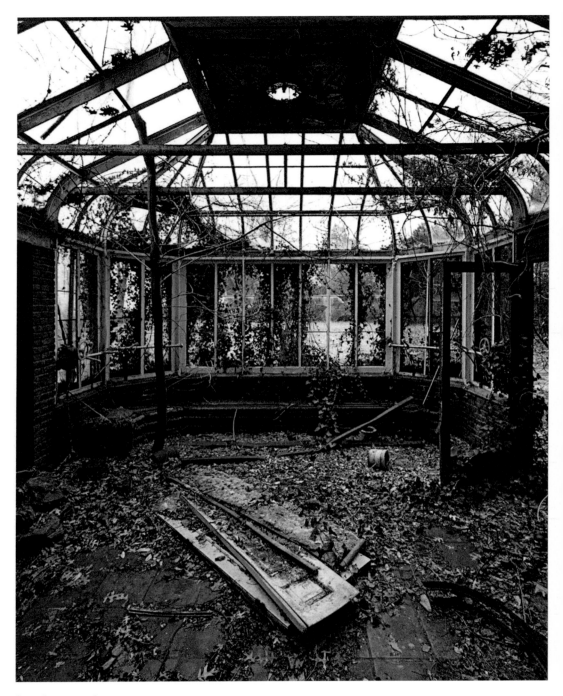

Greenhouse number one.

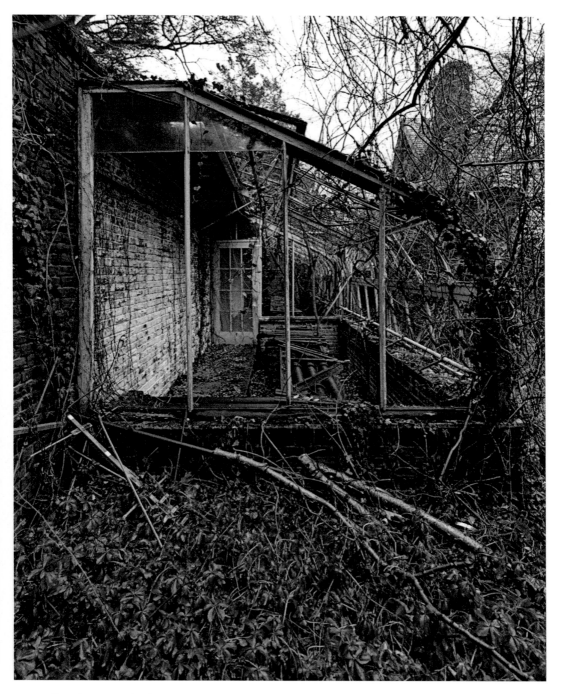

Greenhouse number two.

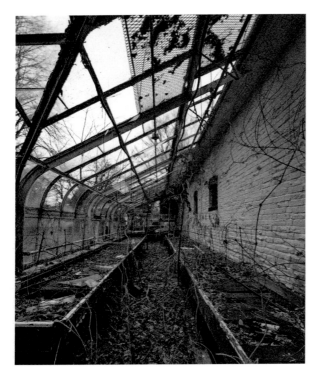

Left: Greenhouse number three.

Below: The "Doll House," entirely empty and located upstate.

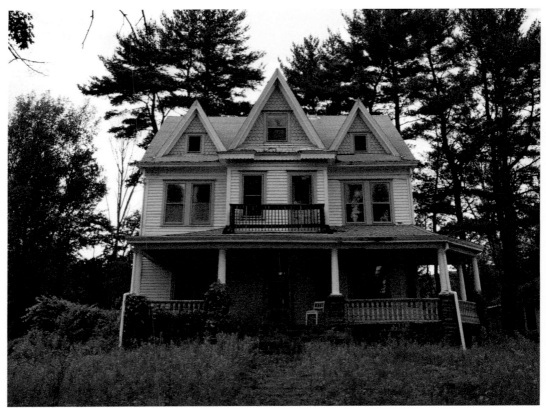

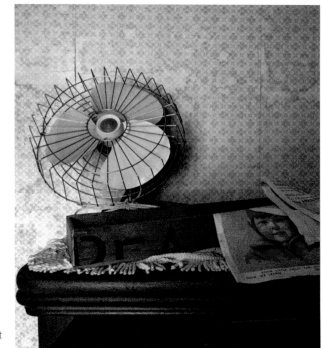

Right: Old belongings left in a farmhouse.

Below: The "Unbearable House of Bugs," the nearby water and swimming pool in the backyard make it impossible to be outside for long.

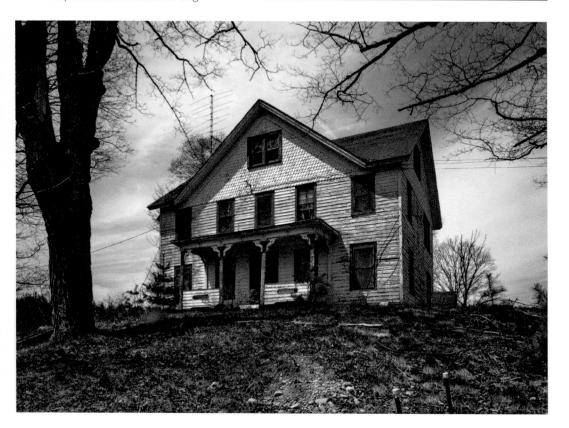

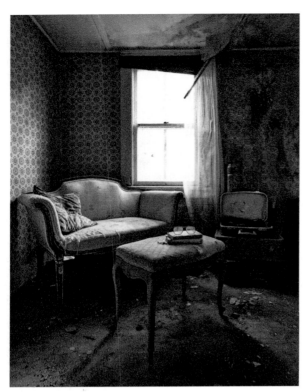

Left: The comforts of home left behind.

Below: A small roadside house engulfed in green.

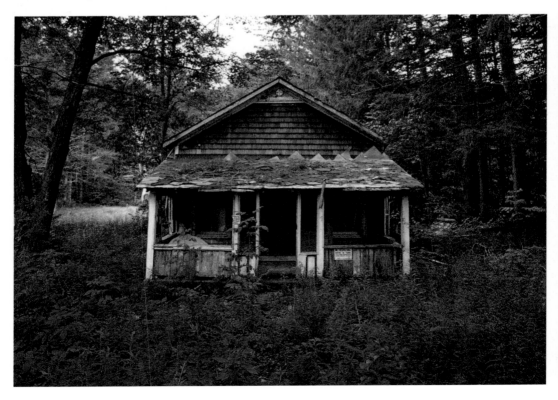

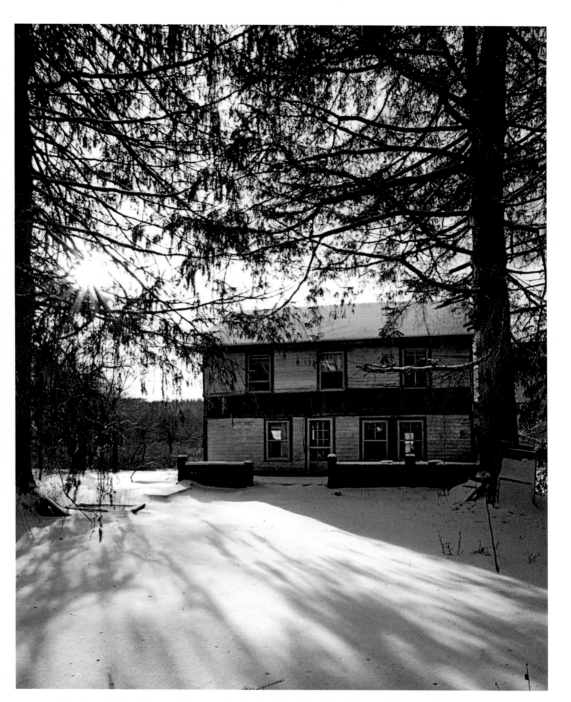

Side view of a forgotten upstate home, located on the side of the highway. There was ice underneath the snow in front of the house, most likely a lake.

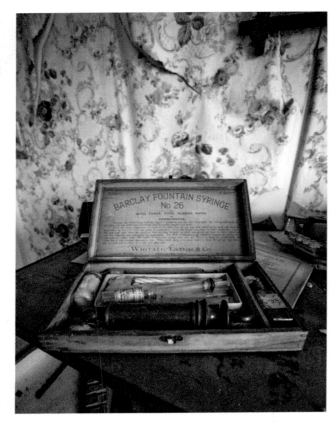

A home enema kit from the 1800s.

Upstate New York was once a thriving summer destination for New York City couples and families. The Catskills were dotted with farms owned by Jewish families, who converted their houses into small hotels and built colony bungalows or boarding houses. These summer accommodations in the "Borscht Belt" were popular with city dwellers who wanted to escape the stifling congestion of the city for fresh mountain air and nature. Most of these resorts are now ghost towns. The period furniture and decor in their vacant rooms take you back to the 1970s, or beyond—to carefree, joyful summers.

This resort opened in 1903 as a high-end vacation destination. Like other resorts in the area, it was forced to close in 2009 after years of financial struggle. However, there is hope that the property will once again be renovated and given life again.

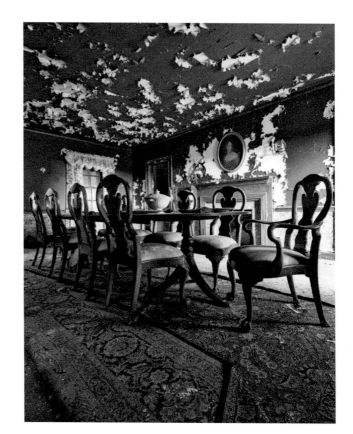

Right: An elegant dining room overseen by a formal portrait of the lady of the house.

Below: A former room of music and joy.

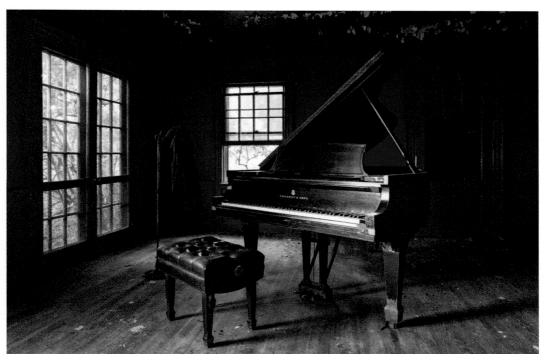

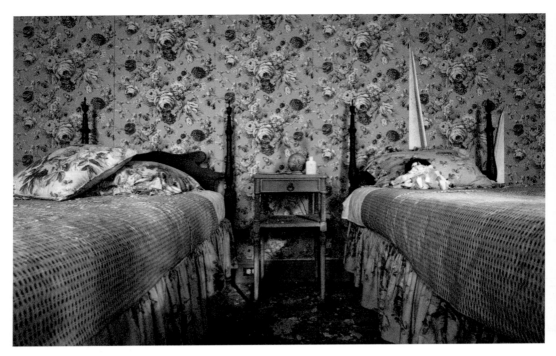

Beds left freshly made in the little girl's room.

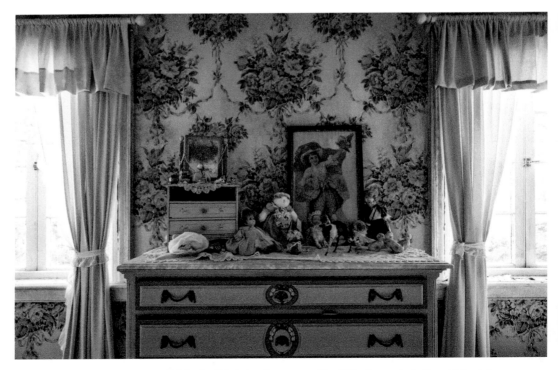

This house was surprisingly intact. All the family's belongings seemed to still be there—including children's toys, bikes, clothes, jewelry, antiques, crystal, and more. The house has since been boarded up to prevent vandalism and theft by local youth.

Right: Honest Abe hangs on the wall and an antique child's toy.

Below: In the Catskills.

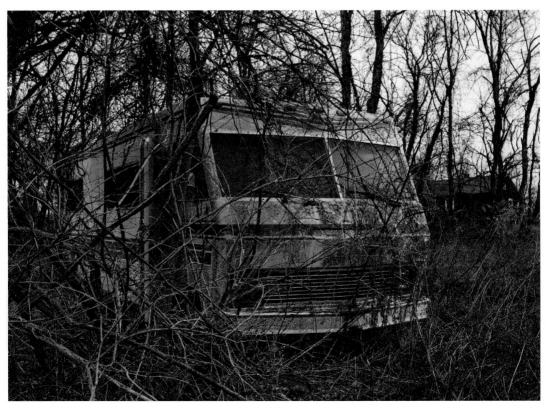

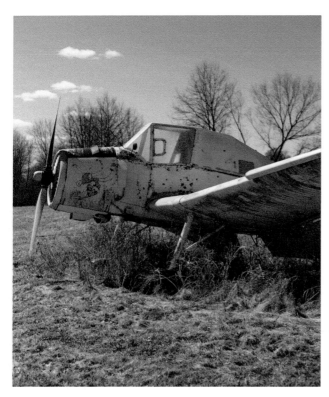

Left: What once soared sits covered in weeds and grounded.

Below: Hiding among ferns in the Catskills.

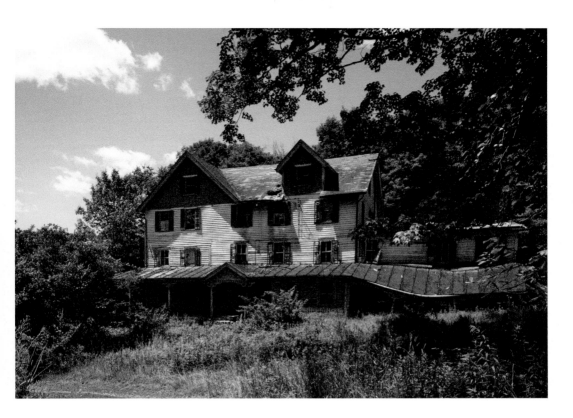

Above: There's relatively little on the grounds of the Dell boarding house that gives you a sense of its history. Based on the items found inside, the house seems to be from the early 1900s.

Right: What a surprise to find straw mattresses in the fourth-story attic—especially since this boarding house's first floor was inhabited until 1995. The bottom floors are collapsing from the weight of old furniture, and the upper floor is rotting away, assailed by Mother Nature.

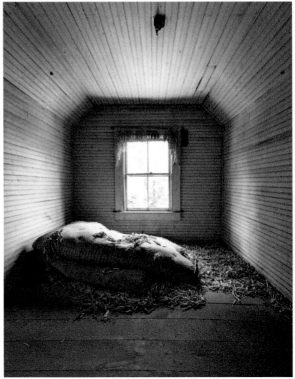

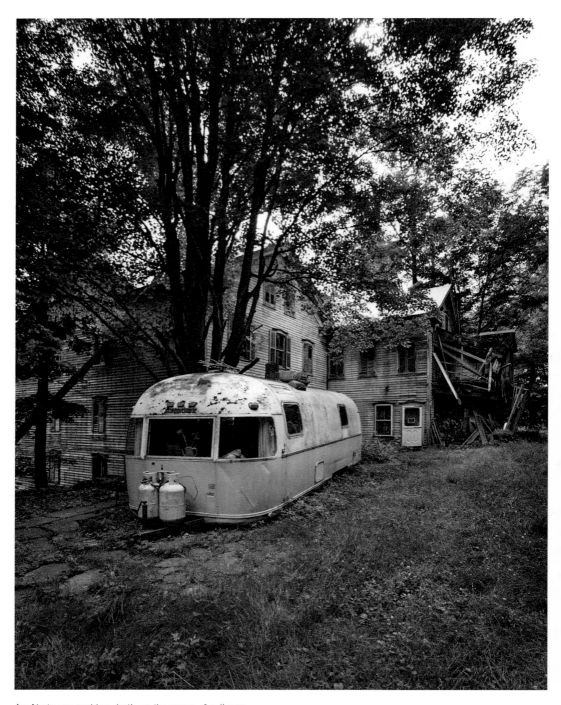

An Airstream and inn, both on the verge of collapse.

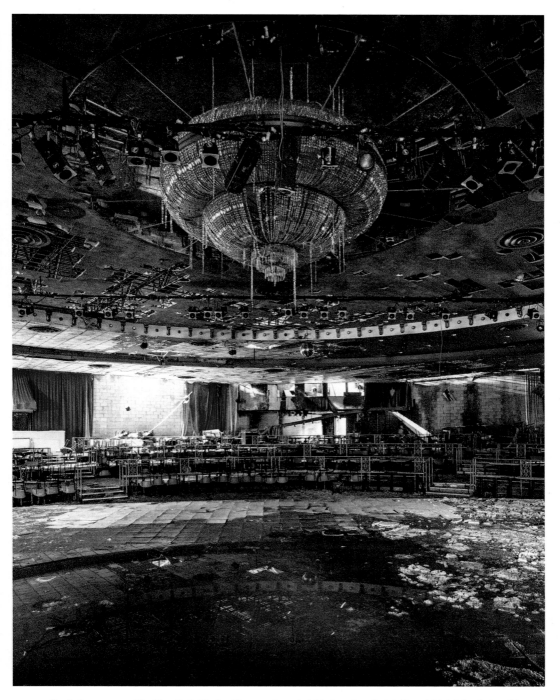

For forty years, wealthy New York City families vacationed at this luxurious hotel. The nightclub hosted well-known celebrities and musicians, such as Woody Allen and Tony Bennett. After the owner's death in 1978 and changing tastes in entertainment, the hotel struggled but managed to stay open until the fall of 1988.

Left: A bungalow window with paint that has chipping for years.

Below: This small motel has is virtually unchanged since the 1970s. Many of the rooms are unlocked, but there's no decay or vandalism. The other buildings on this property have been converted into apartments.

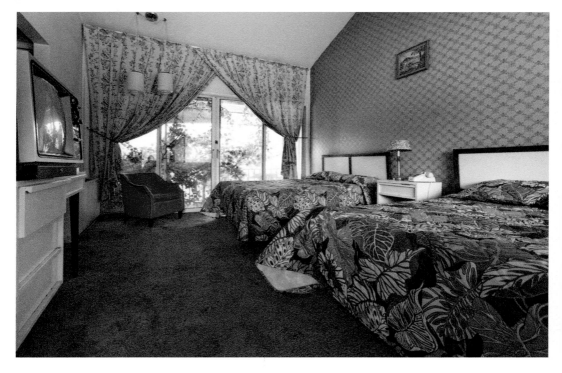

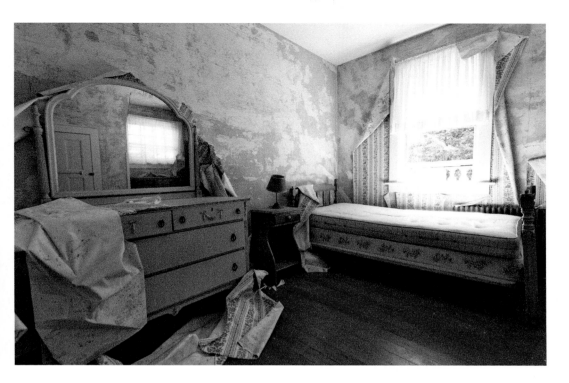

Above: Wallpaper peels from the walls of this old inn.

Right: There were vintage jukeboxes, radios, and a porcelain washing machine. There was even a desk with a vintage typewriter and the skeleton key still in the drawer. This bench and the antique skirt dress form are in a room on the top floor.

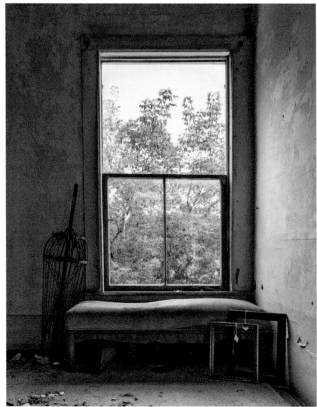

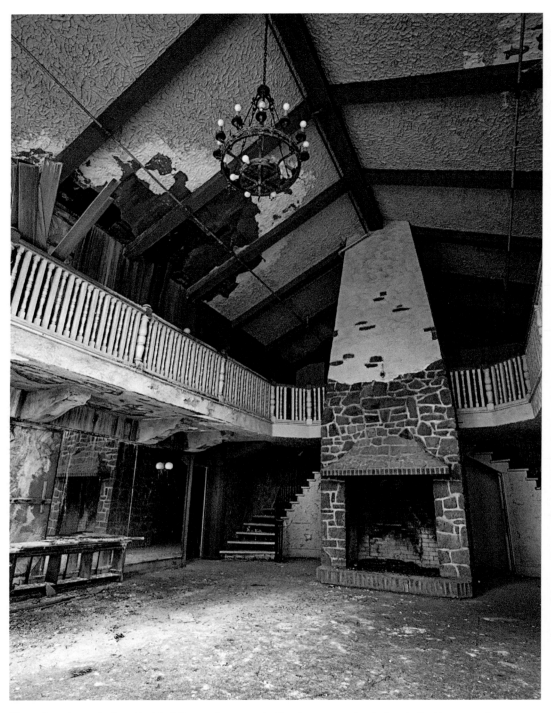

The main entrance to the oldest building on the property. Guest rooms are located on both sides, as well as behind the grand fireplace.

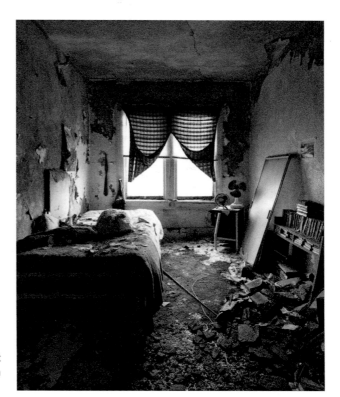

Once a guest room, this became a worker's humble abode. Mossy green growth now covers this bedroom's wet carpets, where paychecks were still in envelopes.

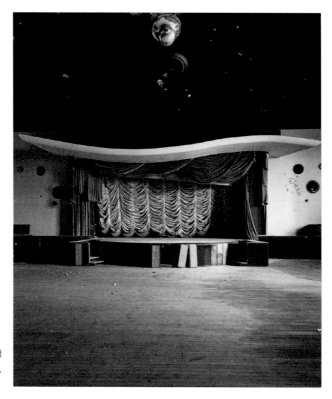

The hotel's expansion in the 1950s and 60s added in a stage for performances, indoor pool, and fitness room.

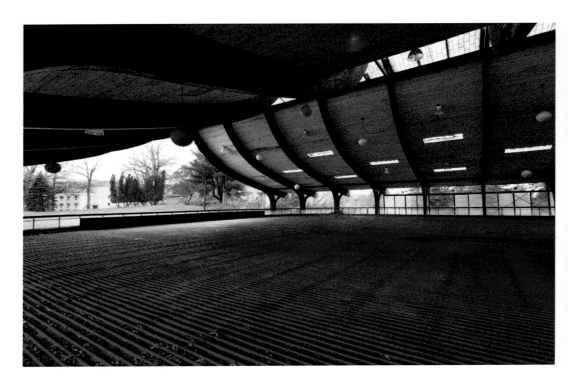

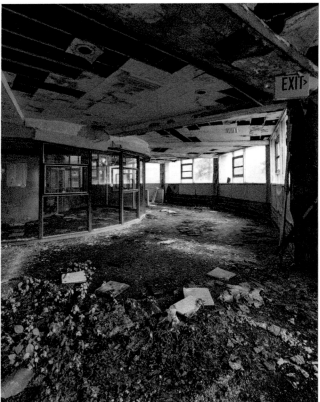

Above: The property also had an ice-skating rink and ski lift.

Left: Icy moss in one of the main hallways.

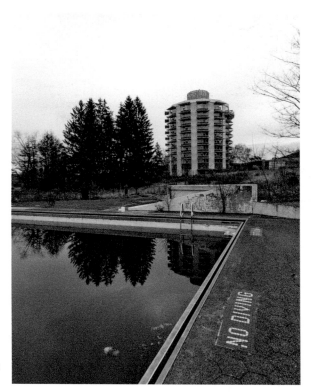

In 1964, the resort constructed a ten-story dodecahedron tower. The bottom floors appear newly renovated and bare, while the tower's decaying top floor are filled with elegant furniture.

Children's playground toys, located along the cliffs of a bungalow colony

Spofford Juvenile Detention Center in the Bronx closed in 2011. Shortly after I visited this location, vandals started to graffiti and the homeless started to pillage the building. As more people found this site, it became such an eyesore. Spray paint covered the interior and exterior walls, rendering the place unrecognizable. Fortunately, this location will be given new life and will be reborn as affordable housing.

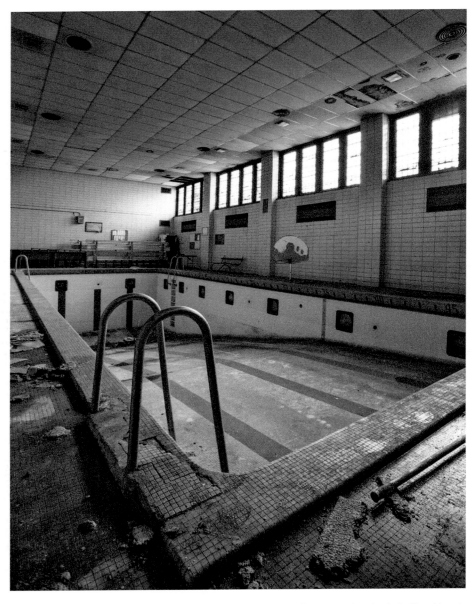

The site has a recreational pool and indoor basketball court as well as an outdoor basketball and tennis court enclosed in the two courtyards.

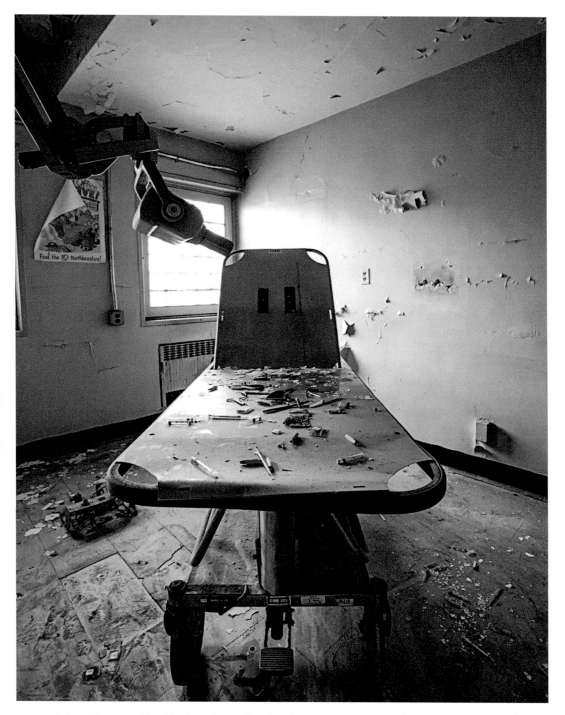

A dental X-ray machine. Used needles and handmade weapons have been left on the gurney and the floor.

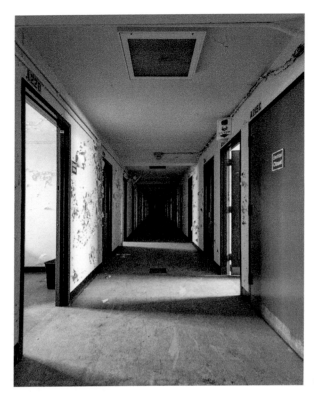

One of the many hallways of detainee cells.

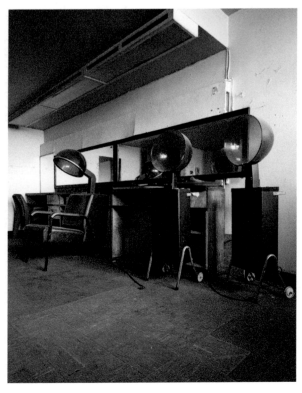

The hair salon.

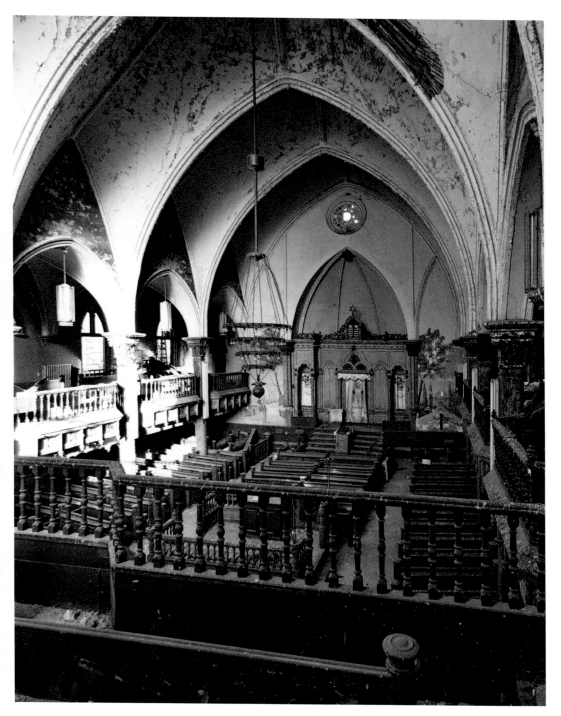

Beth Hamedrash Hagodol was an Orthodox Jewish synagogue built in 1852 on the Lower East Side in New York City. It was the first Eastern European congregation founded in New York City and the oldest Russian Jewish Orthodox congregation in the United States. The synagogue was closed in 2007 due to the decline in congregants. At one point, community members hoped to restore the synagogue as an educational center, but in 2017, the building was set on fire by a local teen and the property has since been leveled.

Growing up in a Roman Catholic household, I was required to attend church and religion class as a child. I recall a time when the priest at a confirmation class told us to decide for ourselves if we wanted to practice or not. As I entered my teen years, I stopped being a practicing member of the church and sought more secular answers to life's questions. As an adult, I can't help but smile at the irony of where my interest in photography often leads me. Many times, I find myself in churches, synagogues, and other edifices of formal religious congregation. Regardless of my faith, I find churches one of the most enjoyable places to explore and photograph. The architectural elements and hand-painted ceilings are breathtaking. These older churches and cathedrals have a certain ambience that cannot be duplicated in modern constructions. Unfortunately, as these places of worship decline in importance in contemporary New Yorkers' lives, it's become commonplace to see vacant religious facilities.

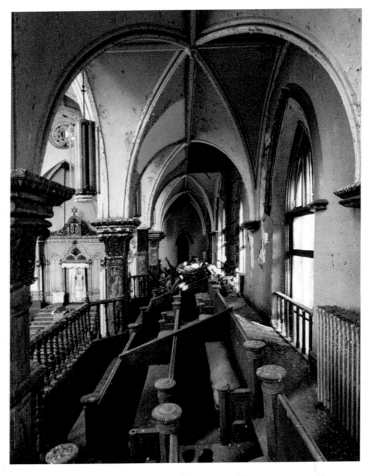

"Bird Shit Synagogue," so nicknamed because all the pews and railings are covered with pigeon droppings.

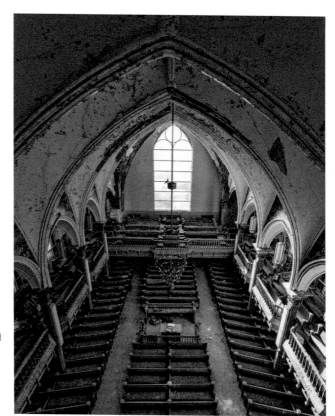

Right: Bird's-eye view including a bird on the chandelier.

Below: This Roman Catholic Church built in 1842 has stunning hand-carved wooden details.

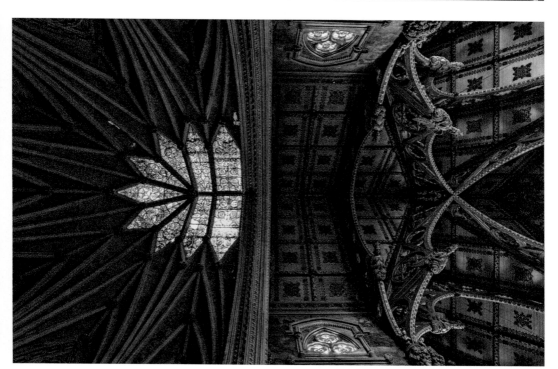

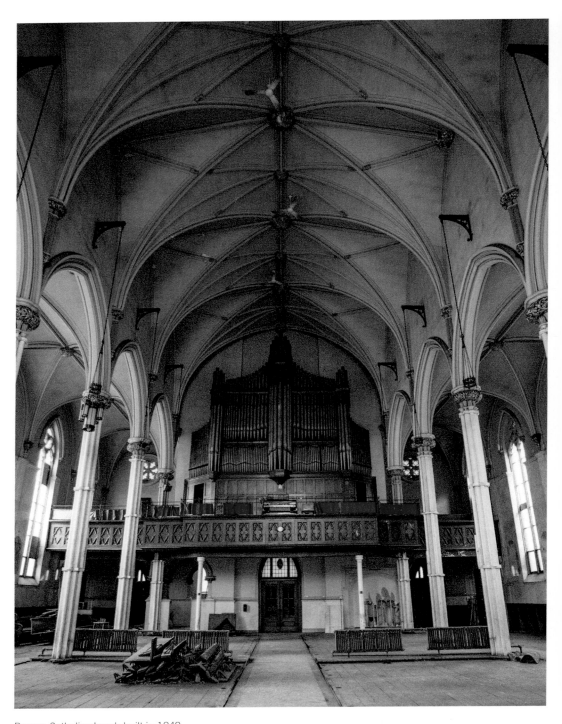

Roman Catholic church built in 1848.

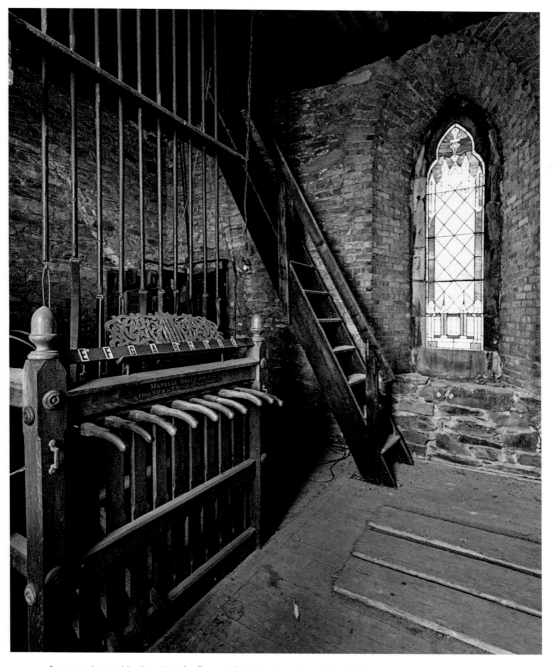

An organ located in the attic of a Roman Catholic Church built in 1842.

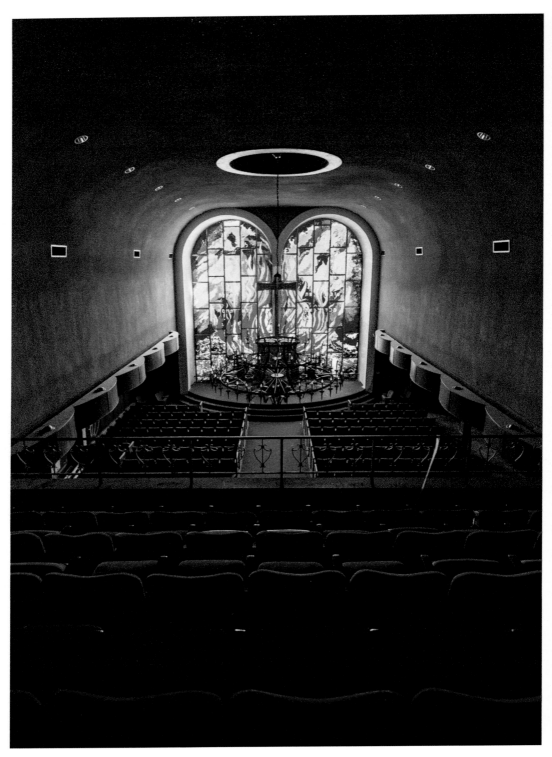

"Fire Synagogue," founded in 1956 and located on Long Island. In the center of the stained-glass window is a cross on fire with Hebrew characters.

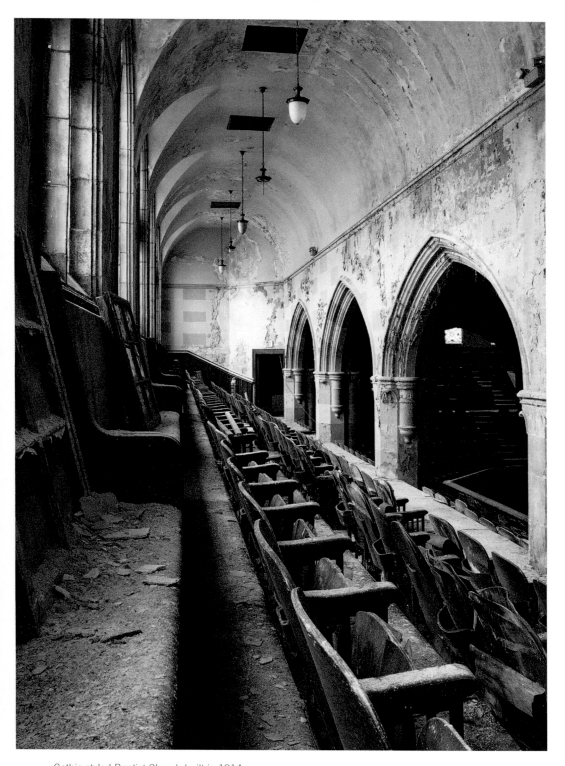

Gothic styled Baptist Church built in 1914.

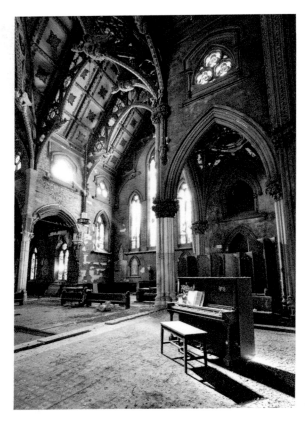

Left: A light beam shines on the piano in this Roman Catholic Church built in 1842.

Below: Our Lady of Loreto ceiling. A Roman Catholic Church located in Brooklyn. Demolished in 2017 to make way for condos.

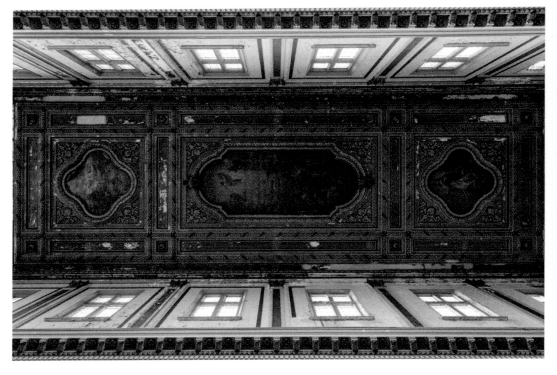

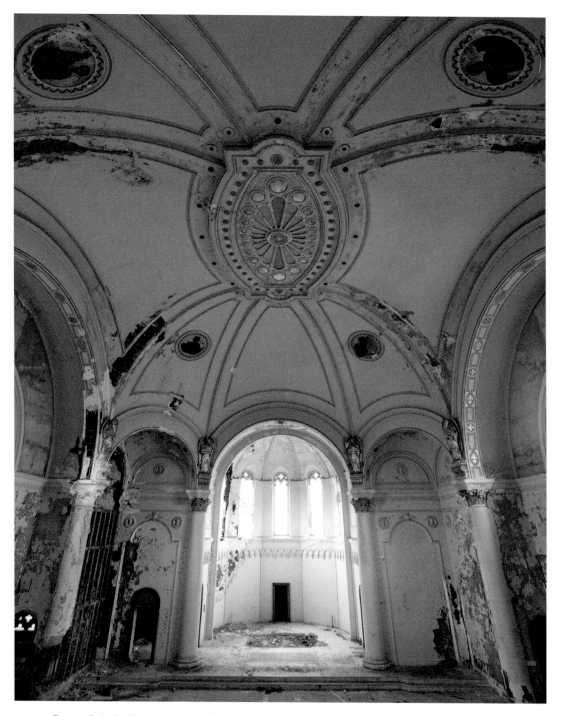

Roman Catholic Church built in 1908.

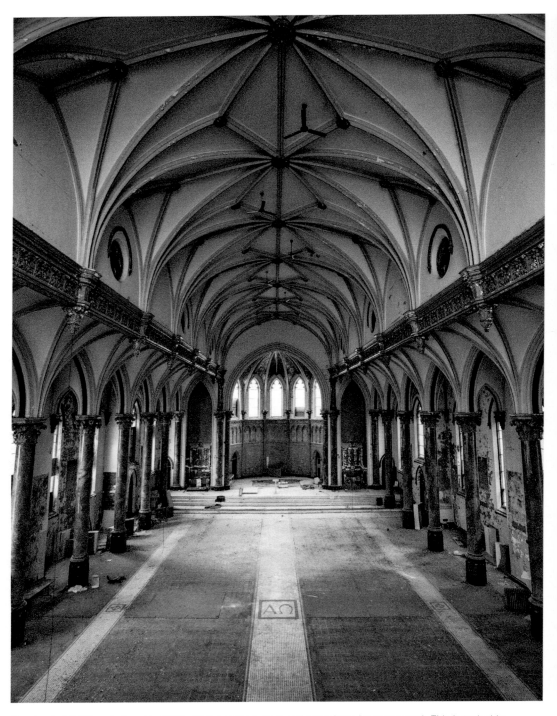

Constructed 1871 and closed in 2010. All the stained glass and pews have been removed. This is typical in many abandoned churches.

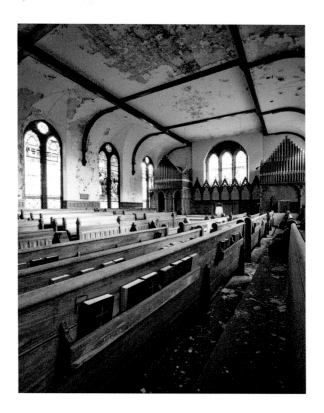

Bibles in the pew of an 1879 chapel.

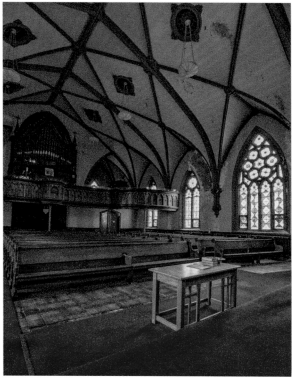

A local child stated this church was
abandoned. But after entering, a cell
phone began to ring.

St Mary's Convent in Peekskill was built in 1876. The convent moved to a larger property in Greenwich, Connecticut, in 2003. It is said to be the oldest Episcopal religious community in the United States still in existence.

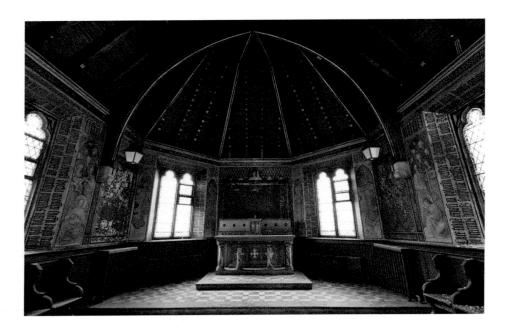

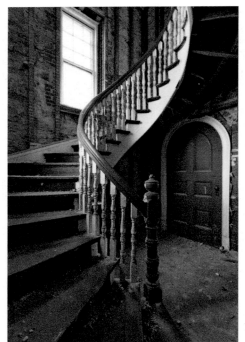

Above: One of two chapels located on the second floor. Surprisingly, the hand-painted walls, which were decorated before World War I, remain in remarkably good condition. This chapel was used primarily to provide services for ailing nuns when the convent was at its largest. With the decline in membership and the school enrollment, the small chapel was used for most services, while the larger chapel, which was constructed in 1896, was used for special functions.

Left: Most of the convent was gutted in 2003 when the building was vacated. The convent is now being converted into a restaurant and other recreational spaces for a condo complex. The spiral staircase as well as the remaining older architectural elements will be preserved in the rebuild.

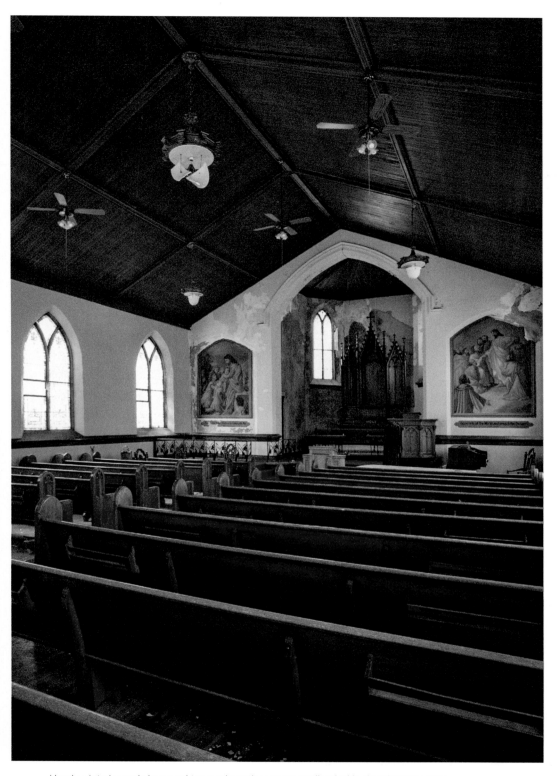

Hand-painted murals in a rural town, where the streets are lined with abandoned houses.

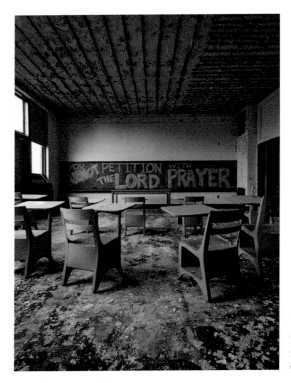

One of the classrooms in a Roman Catholic Church, constructed in 1923. The church ceased serving as a school in 1979.

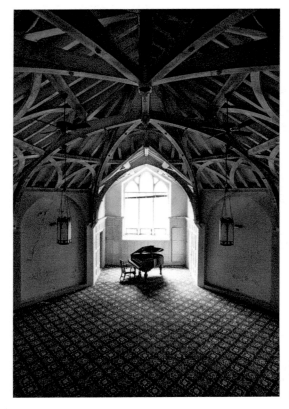

Once used as a music room for a former estate. This beauty became the common area of an assisted living home.

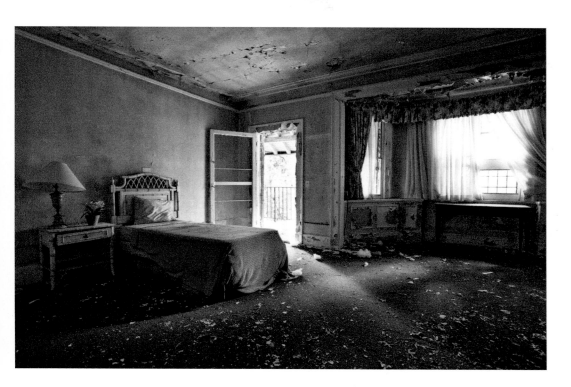

Above: A former patient's room at the home for the elderly.

Right: Built in 1936, the Hippodrome Theatre in Loch Sheldrake was demolished July 2017.

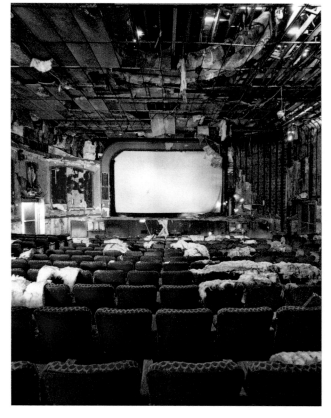

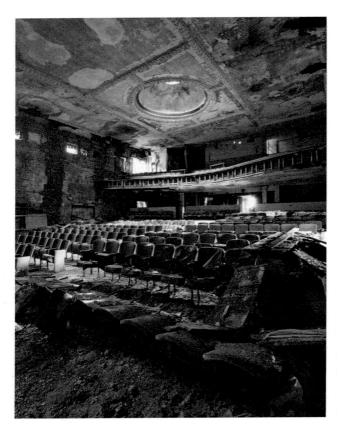

Left: The Sattler Theatre, located in Buffalo, was built in 1914. The property allows photographers to access the building for a donation going towards the preservation.

Below: Vacant theater with part of the roof collapsing.

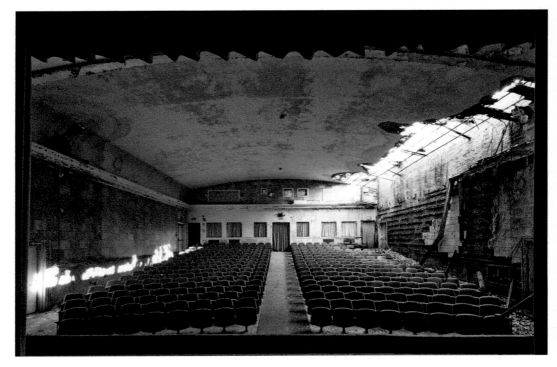

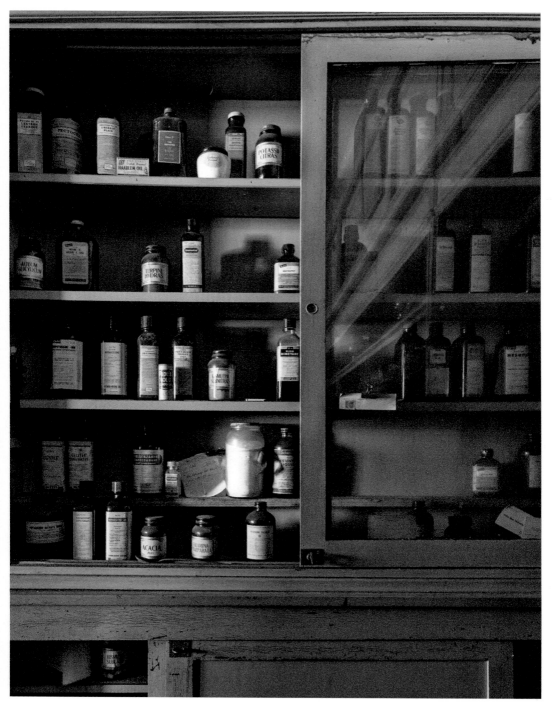

This pharmacy appears to have closed its doors in 1978. Since it is located in such a small rural town, all the medicine and goods for sale remain on the shelves.

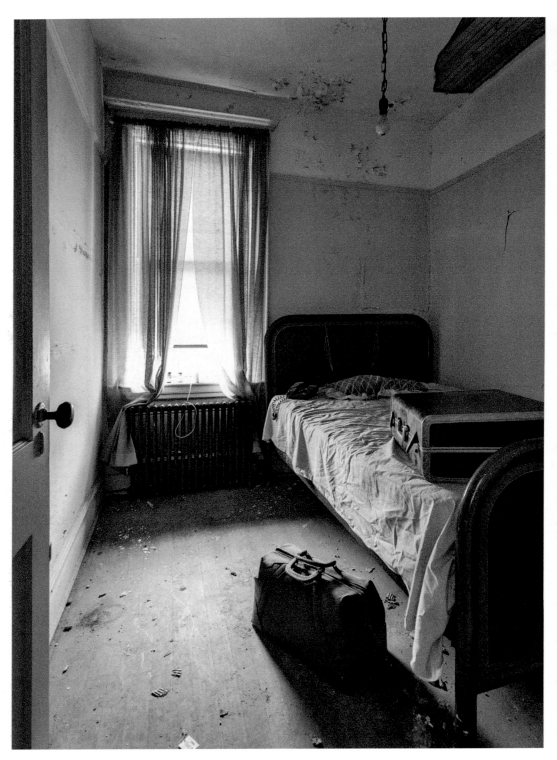

A bedroom located in the apartment above the pharmacy. In the kitchen, there were rain checks to the grocery store dating back to 2005. In one of the other bedrooms, there was a handmade Ouija board.

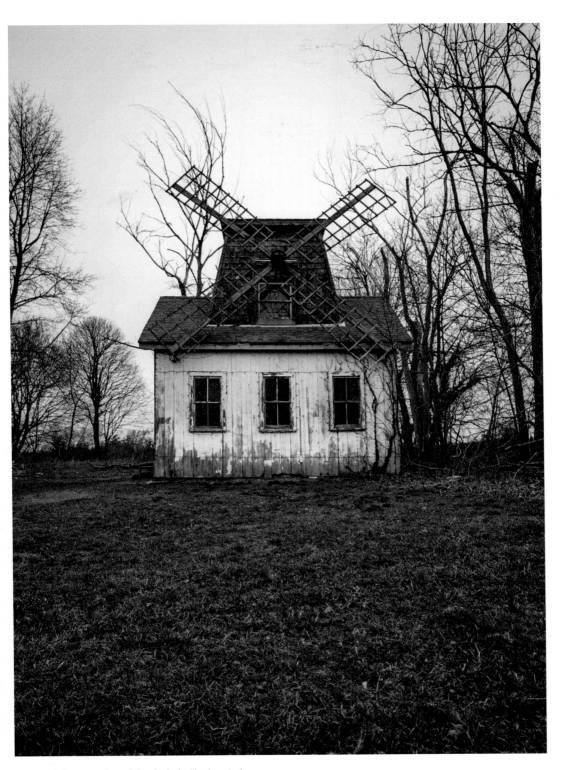

A forgotten Long Island windmill, close to home.

WORKS CITED

Abandonedny.com

Abandonednyc.com

Abandonedonline.net

Afterthefinalcurtain.net

Asylumprojects.org

Atlasobscura.com

Buffalohistory.com

Catskill.net

Hvmag.com

Lohud.com

Ny.curbed.com

Opacity.us

Recordonline.com

Scdemocratonline.com

Theghostinmymachine.com

Theotherhudsonvalley.com

Wikipedia.com